What C *Book . . .*

"A solid memoir about a life reconstructed. Chilling, thrilling, and thought provoking."
—Pearry Teo, director, *The Gene Generation*

"This is a thoughtful book, and an important one."
—Christine Ducommun, author,
Living with Multiple Personalities

"The images created by this artist, like the words in this book, will quietly sear your heart in ways only loving 'right' can do."
—Ron Russell, author, *DON CARINA: World War II Heroine*

"A truly extraordinary story. A surprising disclosure of dark secrets dragged into the light."
—Christine Belleris, Beyond Words

"Spellbinding. If you've yet to define yourself as a strong person, an activist, this book will remove all self-doubt."
—James Wilson, therapist

THE REBIRTH of Suzzan Blac

SUZZAN BLAC

BETTIE YOUNGS BOOKS

Disclaimer: This is a true story, and the characters and events are real. In some cases, the names, descriptions, and locations have been changed, and some events have been altered, combined, or condensed for storytelling purposes, but the overall chronology is an accurate depiction of the author's experience.

About the Cover. The art on the cover, called *Blue Hair* (2008), oil on canvas, 35" x 53", was created by the author, who explains: "I had been asked by my agent for six large pieces of work for my solo exhibition shows. As I was preparing, I saw a documentary about the detrimental psychological effects of plastic surgery, and also a show about pageant princesses. I watched these little girls being turned into mere objects—some conditioned into this life as babies. As I began to paint, I remembered how I was brought up in 'pretty' dresses and frilly knickers with bows in my hair, and how so many people referred to my beauty alone. As I got older, the emphasis was on how to attract and keep males using my beauty. I was just a pretty ornament, groomed to attract a male, preferably a rich man who could look after and pamper me, and that alone would be the key to my happiness. The painting you see on the cover is what emerged. This painting took me two months to complete; there are ten layers to it. The hair alone took over 50 hours."

Cover design by Tatomir A. Pitariu and Jane Hagaman
Edited by Mark A. Clements and Christine Belleris
Photo of Suzzan by Dominic Boon

Bettie Youngs Books are distributed worldwide. If you are unable to order this book from your local bookseller, online, or Espresso, you may order directly from the publisher.

BETTIE YOUNGS BOOK PUBLISHERS
www.BettieYoungsBooks.com

Library of Congress Control Number: 2012934496

1. Blac, Suzzan. 2. Family Relationships. 3. Self-image. 4. Art. 5. Inner Child. 5. Emotional Abuse. 6. Sexual Abuse. 7. Sex Slave Industry.

ISBN: 978-1-936332-22-9

10 9 8 7 6 5 4 3 2 1
Printed in the United States of America

Dedication

I dedicate this book to those who have been hurt at the hands of another. My hope is that my story will give you the courage to break the silence and become the person you are meant to be.

Contents

Acknowledgments

First of all, I would like to thank publisher Bettie Youngs for her belief in me, and for "seeing" and "getting" the story. I have to admit that when I sent her a sample of my paintings, though she didn't faint, she checked me out to see what sort of a character I was. And then she coaxed my story out of me—and I dare say, made it more "reader-friendly!" Under her direction I felt nurtured, and it was through her that I saw for myself why this story demanded to seep out of my very pores and make its way in the world. I can honestly say that under her care, I've grown. Thank you Bettie, for your generous insight and wisdom. If this book helps others, you have a hand in bringing about a safer and kinder world.

I'd also like to thank the Bettie Youngs Book Publishing. I would especially like to thank Elisabeth Rinaldi—who read and critiqued the first draft of this manuscript; senior editor Mark. A. Clements, who shaped the story and thankfully, kept its integrity. Mark literally painted the words, and within a cover, framed them, too. And then to Christine Belleris, whose craft was more than I could have ever hoped for. She finely honed my words, preparing them for publication—and then did so again, and yet again. Thank you graphic designer Jane Hagaman for the beautiful layout and chapter design. And to Tatomir Pitariu and others in Bettie's office who helped birth my book, literally. To all of you: thank you for such love.

I would like to also thank Colm O'Gorman, Claudia Lifland,

and all of my fans and friends for their support, encouragement and belief in me—for I could never have exposed all of me . . . all of my truth . . . without them. I would also like to thank my oldest and dearest friend, Jane, for always being there for me, and for being the person I trust most. I love you.

I would like to thank my sister for staying with me, supporting me, and for her unconditional support of me and for believing in my possibilities and dreams. We were once driven apart by terrible circumstances, but now we are true sisters—to the end. I admire you and I love you.

I would like to thank Simon for all of your love and support. You were the first man who accepted, understood and yet still loved me completely, even after knowing my story. I love you.

I would like to thank my children, Abigail and Dominic, who gave me the reason and strength to fight and conquer the odds against my emerging into my "true self." I gave birth to you both . . . but it was you who gave life to me. My love for you is eternal.

I would like to thank my granddaughter Lilly for reminding me just how innocent, precious and beautiful a child can be. She is beloved, and the main reason I need to do what I can to help other children. If I only save one more . . . and one more . . . and still one more, then all that I do matters. Knowing this gives untold meaning and immeasurable reward to my life.

And to you, my readers, may this book find a home in your heart, and help you become an advocate for rescuing the children who, each day and night of their lives, live in a red bed.

Prologue

On the 28th of August 2000, I took a writing pad and pencil and walked to a local spot overlooking the Atlantic Ocean off the coast of Devon, England. I sat myself on a wooden bench, alone with my thoughts. As I was scribbling down some thoughts in a journal, I heard a commotion and looked up to see a family of four walking along a cliff path.

The mother was holding a baby and gazing out to sea while the father shouted at his son, a toddler who was lagging behind. The father abruptly marched down the slope and punched the child in the head. As I stared wide-eyed and open-mouthed, the father kicked the boy so hard he flew right up into the air. The mother did nothing; she didn't even glance toward what was happening.

My pad and pencil fell to the ground as I ran toward the stone wall separating me from them. I shouted to draw the man's attention away from the child: "Stop it! *Stop it*, you bastard!"

Upon hearing me, the father flung his arms into the air. "You don't know what he's like!" he shouted.

I screamed back, "Leave him alone, he's just a small boy, and he will hate you . . . he *will* hate you!"

The family began to walk away as I ran down the hill to tell them more. By the time I finally got there, they were nowhere to be seen. I sobbed in anger and defeat that I couldn't follow them, get their address and report them to the police. Instead I

walked home and wrote the date and the incident in my note-pad.

I also wrote that tomorrow I would tell the world a secret I'd been harboring for some time. This book reveals that secret... and the ways fate intervened to make it a story far bigger than my own—and one that would point me in the direction of my calling. From then on, I would strive to expose the dark, secret world of child abuse—physical, sexual and emotional.

A world I knew far too well.

The Rebirth of Suzzan Blac

Welcome to the World

My mother met my father at a dance hall in Lozells, Birmingham, England, in 1956. Ruby was just seventeen years old and Harold twenty-eight, a good-looking man of Irish descent with twinkling blue eyes and a head of thick, black, curly hair. His irresistible smile and pencil-line moustache emulated those of Ruby's heartthrob, Errol Flynn. She immediately fell for Harold's charm and wit.

Ruby was a dark-haired, brown-eyed, petite woman who loved to laugh and flirt. Her goal in life was to meet a man rich enough to look after and pamper her. But such men were few and far between, so in her irrepressible lust, she had to make do with Harold.

That first evening, Harold bought a few rounds of stout, followed by a fish-and-chip supper, which automatically entitled him to an obligatory "quickie" back at his bachelor's hovel in the bedsit land of Erdington—a place full of drifters, where no one knew your name or remembered your face.

A few months later, after a succession of similar quickies, Ruby fell pregnant—and Harold magically disappeared into the night. Or, as Mother often told us, "Your bastard dad buggered off to London and left me in a bloody Mother and Baby Home."

This was how Mother gave birth to John, her first "accident," as she liked to call all her children. By the time John was two years old, Father had returned and married Mother. Quickly "knocked up" again, Mother produced her second accident—a daughter she named Ann.

The family of four moved into my grandfather's small "two up-two down" terraced, back-to-back house in Handsworth. Four months after Ann's birth, Mother found herself pregnant with her third and worst accident yet: me.

I was born on the twenty-third of June 1960, during a midsummer's eve thunderstorm. Mother resented me even while I was still in the womb, because—as she constantly reminded me and told everybody else—I lay on her spine for the entire pregnancy. I crippled her, she said, by causing her severe sciatica. Although the doctors tried several times to reposition me *in utero*, I always returned to lying on her spine. It was one of her favorite stories.

One afternoon when I was very young and out shopping with Mother, an old woman stooped down to my level and told me how pretty I was.

"She almost killed me," my mother told the woman. "She caused me more agony than I can describe."

The woman's smile turned to a shocked frown. Looking at me, she shook her head. "Noooooo . . . did you cripple your own mother?"

As always, I whispered, "Yes," and hung my head in shame.

One week after my birth, and still with no name, I was taken to my grandfather's house in that poverty-stricken Handsworth slum, where children of all ages were left to their own devices on dirty, cobbled streets, amongst the foreboding alleyways and the derelict Victorian houses that gave shelter to unfortunates with no fixed abode or hope. I spent much of my childhood on those streets which, although sinister and menacing, were at least a place to belong; a sanctuary to escape to from the far greater horror that was my home.

My sister did not take well to my arrival; her greeting consisted of biting me until I bled. She was an extremely angry child, a characteristic that lasted well into her teenage years. I was terrified of her. Mother, on the other hand, admired her temper. My sister had "a lot of spirit," Mother said; "She reminds me of myself."

My father worked a menial job, so there was hardly any money coming in. We did not even have basic amenities such as heating and hot water. There was no bathroom or toilet; if you needed to relieve yourself, you had to take a long walk to the public toilets or avail yourself of an enamelled bucket or a chamber pot. Of course such containers had to be carried regularly to the public toilets and emptied—a particularly unpleasant task, especially during inclement weather.

Downstairs, my entire family lived in just one room that served as a lounge, kitchen, and diner. The only other downstairs room was out of bounds, kept spotlessly clean and shut off in case of unexpected visitors, although I can't ever remember any visitors, except the professional photographer who once came and took a family portrait.

On the other hand, I do vaguely remember my grandfather, who was blind, defying Mother by going into that room quite

often. He would sit in a heavy old armchair and suck on his pipe while clicking his dentures in darkness lit only by a burning ember of tobacco. I heard him mumbling inane rants, lost in his own ghostly world.

He died in that chair, alone and miserable—which, according to Mother, was what he deserved. "He was a fucking pig" who had committed "her" mother to a mental asylum after their house was bombed during the war and she delivered stillborn twins. Although the hospital staff had promptly taken the dead babies away, Grandmother had been convinced that they were still alive and desperately needed her. She would search and search for them, sometimes all through the night, calling down drains, shouting in alleyways and sifting through dustbins. In those days, people who suffered psychological trauma were dismissed as defectives, and would often be committed to mental hospitals to be pumped full of drugs and electricity, neglected and left to rot. I don't know how long my grandmother spent in that hellish place, but she died of pneumonia before reaching her fortieth year.

Mother was fourteen years old when she had to leave school to work in a factory so she could support her blind father. "I slaved over him," she told us. "The bastard couldn't make himself a cup of tea, yet he'd go out every night in search of cigarette ends so he could fill his fucking pipe!"

This is all that I ever knew about my grandparents. To this day I don't even know their names.

Our house was of solid Victorian construction. Visitors, had there been any, would have been greeted by a dark crimson door in the center of which bulged a huge, black, cast-iron knob. As you opened the door you would find yourself confronted with the stairs and, beneath them, the gas cooker. In the middle of

the room stood an old, gnarled, wooden family table, and to the right, a sideboard containing sheets, blankets and towels. In one corner hunched an Ajax-white Belfast sink, and in another corner a cheap laminated dresser that contained the crockery and cutlery. The only source of warmth was a small gas fire bearded by a bright orange rug. A small black-and-white TV perched precariously on a table adjacent to the stairs that led up to two tiny bedrooms. We did not have a car or a washing machine; we didn't even possess a telephone. No one in the area did. That probably accounted for why everyone felt safe leaving their front doors open—there were no burglaries because no one had anything to steal.

Outside lay a small, square patch of grass we called the garden. It had no fence and met a public footpath. Next to the kitchen window stood a metal shed containing corroded junk, a few antiqued gardening tools, and thousands of daddy long legs spiders. Also a mangle (a clothes wringer), which made its appearance every wash day.

Hanging on the outside wall was a small, ancient tin bath that was brought into the house every Friday for family bath night. This was a most unpleasant ordeal, especially during the winter. I can still see the heavy condensation dripping down the window from the endless array of kettles, pots and pans needed to fill the bathtub. Once ready, the seven of us formed a queue to stand in the tub, scrub and get out quickly before the water turned cold. Then it was a fight to get closest to the gas fire, to stop the shivering and clattering teeth. I would put on extra layers of clothes before going up to my damp, metal-spring bed in the room I shared with my sister, brother and grandfather. Sometimes I could not close the curtains to stop the gusting drafts, because the cloth was frozen solid.

Mother never tucked us into bed, or hugged us, or kissed us goodnight, or read bedtime stories. I don't recall ever having a teddy bear or other bedtime comfort toy. There weren't any books in the house. I can't even remember celebrating any Christmases or birthdays either.

One evening when I was three years old, a strange woman came into our house. She wore a navy blue cape and carried a large leather bag. Mother had been in bed most of the day, crying and making funny noises. Father took the strange women upstairs, then came back down and put on the TV to watch a boxing match. After some time, Mother started making terrible, frightening sounds. When I asked father what was wrong, he told me to be quiet because he was trying to watch the boxing. I became upset. He sighed and said, "Your mother's having a baby."

A few hours later, after the strange woman left, we children were allowed to go and see our new brother. His name was Nicholas. I didn't like him very much, as he just kept screaming and screaming. Mother did not look very happy, either. She said, "Another bloody mouth to feed."

One of my earliest memories was when I was around eighteen months old. I sat on a kitchen table wearing a pink nylon, lacy dress while an old couple towered above me, making funny gurgling noises. What follows next is, I'm afraid, rather vague, as I am not in possession of all the facts. Only snippets of information were ever fed to me, by both my mother and father.

According to them, both my sister and I were placed in temporary foster care during early infancy. Not because we had "severe head lice," as we were later told, but because we had

been sexually molested by our uncle, my mother's brother; who was known to be "most unstable." Mother told me that he used to sexually abuse her, too, when she was a little girl. She spoke about it indifferently, as if child molestation was an everyday kind of thing, like having a bad cold. I frowned as she told me my uncle "had a problem with his mind" and had died of a brain hemorrhage in the factory where he worked. He had gotten into a heated argument with another worker, been punched hard, and struck his head on a piece of heavy machinery.

I was twenty-one when she relayed these harrowing facts to me. I didn't question her about them; to tell the truth, I didn't want to know the details. In fact, I wished she hadn't brought the incident up at all, as I couldn't remember anything about it. The knowledge just brought more pain and distress to me. But then, Mother did so enjoy hurting us. By that time we were grown-ups whom she could no longer physically attack, so the only pleasure she had left was imposing emotional abuse.

It was also around this time that she told my older brother John she had tried to kill him while he was in her womb, by throwing herself down the stairs. I saw the hurt in his eyes and felt sorry for him...and angry at her.

Nor was my younger brother Nicholas spared. On his eighteenth birthday Mother informed him that Dad was not his real father. It happened while we were in foster care. Mother had had a nervous breakdown and been sent to a convalescent home to recuperate from the domestic trauma and her brother's sudden and tragic death. She must have convalesced really well, because nine months later, and after some illicit sex therapy, she gave birth to her fourth "accident," Nicholas. I don't know if she told Harold he wasn't the Father at that time. She may have, as she didn't care about hurting people. There was no reason

for any of us to know these upsetting facts—but then, Mother still derived such pleasure from inflicting pain on us, just as she had during our childhoods.

When I was a child, my days consisted largely of trying to avoid conflicts with Mother or find ways to appease her. I once stopped speaking for a long period of time so I wouldn't accidentally provoke her by saying something wrong. Whenever possible I hid myself in cupboards, the shed, the dog kennel. I stayed outside on the streets in all weather. I wanted to be invisible, to not exist. But nothing seemed to work. My tactics only exacerbated Mother's anger toward me. She called me a "sneaky little bitch" and said I was always trying to "get one over her."

Because I also refrained from speaking at school and usually stood in the playground by myself, my teacher suggested that Mother take me to a doctor to deal withy my "insular behavior." Being spoken to in that way by a teacher infuriated Mother so much she literally beat me into talking again.

One day at school, as we students all sat on the big mat during story time, I couldn't stop crying. The teacher became so angry with me that she picked me up and plonked me on a chair at the far end of the classroom. I placed my head on my arms, leaned on the desk and just sobbed and sobbed. All the other children were looking at me. When one of them asked why I was crying, the teacher said, "Take no notice of her, she's just a silly little girl."

I was four years old when I held a paint brush for the first time. It was almost Easter, and the teacher asked us to paint pictures to put on the classroom wall. I painted two bright yellow

The Rebirth of Suzzan Blac

chicks with orange beaks, nostrils, scaly feet and delicate, individual feathers. I also painted two opened egg shells, including finely detailed cracks, lying amongst straw, grass and flowers. I was thrilled with this new-found tool. Before that, I hadn't even held a crayon.

When Mother came to collect me that day, the teacher raved about my work, saying that she had never seen such incredible detail from such a young child before. Mother was not interested. She did not want for me to get "above myself." I was no one special, she told me, and in any event, whatever talent I had was of no use in the "real world."

Mother instilled fear in me every day. In fact, I did not see her as a mother at all. I regarded her as "the enemy," an all-powerful adversary who watched my every move, like a cat watches a mouse, in order to torment its prey before the kill. There was no consistency to what she might say or do; the rules of behavior changed constantly according to her mood. Our home was a war zone and I was an unarmed child soldier, as were my siblings. Their abuse caused me as much distress as did my own.

In one corner of the kitchen, bamboo canes of many different widths leaned against the wall. These were Mother's favorite instruments of punishment, and stood there as a constant reminder of her power. If we broke one of her rules, she would cane us. If we made a mistake—were too loud, had a look in our eye that she didn't like—she would cane us. And if we cried in dread before she caned us, she would only cane us harder. This was how she kept us in line. This was how she prevented us from "getting the better of her."

I still flinch when I think about those canes. I remember how I would adopt the fetal position on the floor, trying to

protect my head from the stinging, whistling blows while peering through a gap between my fingers to gauge Mother's anger level. Watching as the gold cross that hung around her neck swung in unison with every stroke. Although the cane was her favorite form of discipline, sometimes her temper was so instantaneous and out of control that she would use anything close at hand as a weapon.

My weak, apathetic father also suffered under her rule. "Always watching TV or got your nose in the fucking paper, you useless bastard," she would rant. And although Father's survival strategy was to shut himself off from the general carnage, he would nevertheless sometimes become the target of her rage. Once after he dared talk back to her, she gave him an almighty smack on his nose with a metal cooking spoon. He grabbed a handkerchief, held it to his split nose, and walked out of the house.

We children never had that option. We could never just walk away. I envied Father that.

Although Mother told me I was a selfish, sneaky, crafty little bitch who was always up to no good, I never considered myself naughty or bad. For one thing, I was too frightened to be either of those things. But that was bad, too. As Mother often told me, I was a "titty baby," a child lacking any spirit or fortitude.

Mother's definition of "naughty" was impossible to pin down. It changed from moment to moment, suggesting that Mother's vision of "power" was based on instilling terror in small, vulnerable children. She made it clear to us that because she had "had it bad" growing up, so would we. Eventually, she would destroy her children's minds, bodies and souls. She would, in effect, eat her own young.

When I was about four years old, I tripped and fell down the

stairs. During the tumble I knocked over the enamelled bucket that sat on the widest step where it served as our toilet. Falling together, the "shit bucket" (as Mother called it) and I crashed through the door and into the family room.

As I skidded through that day's deposits of urine and feces, I saw mother's face contort into an expression of horror. She reached for a mop and then beat me with it until the handle broke in half, screaming, "Clean up your fucking mess!" As my tears splashed into a puddle of urine, I looked up at my mother's hate-riddled face and told myself that, no matter what she did to me, I would *never* become like her.

One summer's day in that same year, my sister and I lay on our tummies on the small patch of grass outside our house, taking turns lifting our dresses to reveal our bottoms to passers-by. As we giggled in our innocence, Mother came outside to empty the tea leaves down the drain. Our laughter ceased abruptly as Mother's face twisted. "Get in this fucking house now," she hissed. We immediately obeyed, not that we understood why she seemed to be so angry.

Inside, she bent us over the settee, pulled our dresses over our heads, and removed our knickers. Then she caned our bare bottoms with all her might, chanting "You dirty, evil, filthy, fucking bitches!" with every stroke.

So that was it. That was my life. It was hard, terrifying, brutal. It was pain, apprehension, cruelty, distress and fear. But I had no knowledge of any other choice. Endure or die. Black and white. Take it and like it! It was the only life I knew; it was all that I was . . . *this* was my normality.

Years later, during my recovery sessions with a therapist, I asked her why, out of all my horrific memories, I always became the most emotional over a silly, insignificant image: Mother holding my tiny hand as we crossed a busy street. The therapist said the image was immensely significant because it was the only time in my life that Mother actually protected me. I had clung to that single memory of her being a true mother to me, if only for a few seconds, because that was all that I had.

Even now, as I write this, tears well up in my eyes and heart for what could have been . . . what *should* have been. I have come to understand many things in my life. But there is one burning question that remains unanswered: if most members of the animal kingdom possess the instinct to protect their young, even with their own lives, how on earth can a human mother not only fail to protect, but deliberately *harm*, her young?

I believe that mothers are the most powerful beings on this planet. They have the power and capacity to create a wonderful life . . . or to destroy one.

Longbridge

I was six years old when our neighborhood was scheduled for demolition and we moved to a three-bedroom flat situated on a social housing estate surrounding the Austin Motor factory. Looking around, I wondered if we had gone up in the world or had sunk lower. I soon learned it was the latter.

Longbridge was a grim, hostile place full of dodgy adults and out-of-control kids. If there were no chores to do, the parents—including my mother—would roar at the children to "Fuck off out of sight!" To me, this was always a bittersweet expression.

Among the base families in our new surroundings, domestic violence was rife. So were infidelities, vicious arguments, fighting, gambling, alcoholism, drug, domestic, animal and, of course, child abuse. Any money coming in, from whatever source—wages, benefits or dirty money—would promptly be spent on booze, cigarettes, gambling and drugs.

This meant that many of the kids in my neighborhood went without food, or in any event nourishing food. I knew two

brothers whose diet consisted of a single bag of chips every day of the week. There was another boy who made himself a ketchup sandwich. If it wasn't for their free school meals, these children would have been severely malnourished.

There were filthy kids wearing filthy clothes and sleeping in dirty beds inside houses that were never cleaned by constantly pregnant mothers. Toddlers ran around bare- and sore-arsed, without nappies, so their mothers could spend a bit extra on more important things like vodka and cigarettes.

Newborns weren't given any special consideration; they'd wail in their prams, faces covered in dried milk, snot and tears, trying to suckle at greasy bottles of formula propped on pillows next to their searching mouths. I once saw a week-old baby sharing its pram with a cat and its kittens. The mother cat washed her babies with her tongue as they suckled, all four purring away quite happily. Even at the time I knew that the cat was a far better parent than the human mother.

Once, at a friend's house, I saw a newborn left unattended on a settee, its leg in a tiny plaster cast, head straining to turn away from a smouldering ashtray in surroundings of indescribable squalor. I actually moved the ash tray myself because I could not stand to see the infant suffer.

Meanwhile several drug buddies of the "doting parents" sat, slouched or lay on the floor watching TV while a naked toddler pulled on the tail of a German shepherd dog that was franticly licking up the ice-cream the little girl had dropped seconds earlier. The next time I went to that house, I saw that the baby had its arm in a plaster cast. Its mother explained that the toddler had jealously "jumped" on the baby again.

The third time I went, the baby wasn't on the settee at all. The baby, I was told, had died.

The world outside our houses was no better. Starving, mangy dogs wolfed down scraps from ripped bin bags strewn amongst unkempt, junk-covered, rat-infested gardens. Communal sheds that smelled of urine, faeces, sexual fluids and vomit were second homes to maniacal kids of all ages. They swigged stolen alcohol. To get high they experimented with all kinds of household substances, no matter how dangerous. They didn't care about themselves, just as no one else cared about them. They had contests to test pain thresholds and endurance, and tested the limits of self-mutilation.

It was mainly within these sheds that I first encountered pedophiles. At that time most of them were pubescent teenaged boys who seemingly didn't like girls their own age, or indeed the pornographic images of women in magazines, as did the other boys. Teenage boys are actually the most prevalent kind of pedophile—it is not that they don't like girls their own age, this is a power thing exacerbated by the hormonal changes. So I added "seemingly" One I remember particularly was named Winston. At the age of fifteen he looked more like a full-grown man than a teenager, but that didn't stop him from preying on little girls. His younger sister, Grace, told us that he would "do it" to her every time his mom left him to babysit while she worked. Like the other teenaged pedophiles, he always targeted very young children like me. In the darkness of a shed one would take me, make me remove my clothes, and fondle me. Sometimes he would do this from behind while making strange grunting noises and jerking spasmodically. I would submit, helpless, to acts for which I had no understanding or even a name.

There was also a disabled boy known as "Creepy," who lurked around the sheds in his wheelchair. He would pin one

of us to the wall with the chair, grope us and himself, penetrate us with his fingers, and afterward offer us sweets. Even as we accepted these gifts he would let us know that if we ever told anyone what he had done, our parents would go to prison and we would be taken "into care."

That idea terrified me, although threats were not necessary. At that age I couldn't have described what was happening in the sheds even if I'd attempted to do so. But I never even tried. Creepy wasn't the only pedophile who used threats to protect himself. Plus who would I tell—my mother?

Our only salvation during these harrowing times was humor, which helped balance all of the bad. Most of our wit consisted of sarcasm. Making fun of each other eased the constant tension and helped us escape the reality of our lives, so we would constantly "take the piss": play tricks on each other.

Displays of genuine affection were so rare that one such incident still stands out in my memory. At school I made friends with a girl named Jenny, who one day invited me around to her house. We walked there from school in the drizzling rain, and although the distance wasn't great, by the time we arrived we were soaked to the skin. Jenny's mother seemed concerned by this, which perplexed me. She fetched a towel and began rubbing Jenny's hair with it while they both giggled. When she started to dry my hair, I felt almost as uncomfortable as I did in the sheds with Winston or Creepy, albeit in a different way. How weird it was to be treated this way. This was not "normal" behavior between a mother and daughter. There had to be something devious going on behind this obvious façade of warmth and affection.

My father had started a new job at a steel mill, and Mother got a job as a barmaid in a local pub. She worked most nights,

leaving Father in charge, and he would often send all us children to bed early to put a stop to our constant arguing and fighting.

Although sometimes my siblings and I got along and laughed together, mostly we despised each other. To a large extent this was a survival mechanism: to divert Mother's attentions from ourselves, we would tell on each other. Although the maneuver was intended to divide Mother's rage, sometimes it backfired. Sometimes she overreacted in a sadistic manner that spared no one.

One morning I ran downstairs and told Mother that my little brother Nicholas, who was around four at the time, was playing with matches in his bedroom. Mother shot upstairs, hoisted Nicholas onto her hip, and carried him down into the kitchen. "I'll teach you to play with fucking matches! You could of burnt the house down, you little bastard!" She lit the gas cooker and thrust his tiny fingers into the blue flame. He screamed and writhed so violently she could no longer hold him, and dropped him to the floor. There he shrieked, clutching his charred hand.

I felt incredibly guilty, and tears of empathy filled my eyes. I had never guessed that Mother would do such a terrible thing to her own little boy.

My turn came next. One afternoon I took some loose change out of Mother's coat pocket and spent it on sweets. I don't know what possessed me to do something so doomed to failure; most likely I just wanted some comfort. But my older brother saw what I did, and after I left the house, he told Mother. When I returned home Mother was sitting at the table eating her dinner. "Sit down," she said. "And don't move until I've finished my dinner."

An agonizing fifteen minutes crept by. I knew she was going to blow, and why; I just didn't know exactly when, or what she would do to me. Finally she took her plate into the kitchen—

and a moment later I heard it crash to pieces against the work-top. Mother burst back through the door, slamming it back and demanding to know why I had stolen her money.

"I—I didn't take it," I said shakily.

She leaned down so that her face was almost touching mine. "I hate fucking liars!" she roared, and slapped me around the head and body for what seemed like an eternity. Finally she grew too tired to continue. "Get to fucking bed out of my way," she spat.

The violence was not restricted to the inside of our home. One summer afternoon a huge black girl punched me in the face while wearing boxing gloves. I almost passed out from the shock and pain. My sister led me into the flat as my nose was bleeding profusely and I was choking on the blood flowing down my throat.

Mother's response was fury—at me. "Look at the fucking mess you're making!" She told me to clean it up, and added that I was stupid for not hitting the black girl back and sticking up for myself.

So, over time my siblings and I learned not to tell Mother if we got hurt by anyone, in any way. We learned to deal with our own problems, no matter how bad, because Mother would not be there for us. We were on our own.

This was how at a very early age I learned to trust my instincts. I became ever more cautious, vigilant. I also learned that when wariness failed and violence arrived, the best course of action was to be yielding, submissive and compliant, to surrender my body to the world rather than fight.

Every time obscenities were screamed into my face, I would deflect them with a sarcastic thought that never reached my lips. Every time Mother beat me I would protect my tears, adopt the

fetal position on the floor and cover my head. Every time I was taken into one of the neighborhood sheds and violated, I would find a way to dehumanize and mentally withdraw myself from the situation. In fact, every time I was ordered to do anything, I obeyed without hesitation or argument. Because I never received hugs or any sign of love, I saw hugs as signs of weakness. The sum of all of these behaviours left me devoid of emotion.

I had begun to build the wall of self-preservation behind which I would hide for years to come. I wanted to be alone inside my protective wall, and never let anyone else in because that world was far too fragile and fine to be damaged.

I hated the outside world—or rather, the people within that world. I couldn't understand why I felt that, since other people in circumstances like mine seemed to just get on with things. They minimized anything horrible and said "Things weren't *that* bad," and told me I was weak, pathetic, babyish and overly sensitive.

To prevent others from bullying me, and to survive being attacked, I pretended to be tough. I learned to take action right away. I also learned to put on an act. No matter what I felt inside, I would not reveal it to anyone on the outside. I wouldn't show tears, fear or pain; I projected the attitude that I could handle anything life sent my way. I integrated myself into their world, with loyalty and smiles—knowing all along that I was not one of "them," and they were not one of "me."

I was a mess: life had sunk about as low as it could go. But I was wrong.

The New Daddy

It happened on a Friday afternoon when I was seven: my siblings and I came home from school to find suitcases and bin liners dumped in the middle of the living room floor. They contained all our clothes, shoes and an assortment of toys. We halted and looked from this ominous vision to our mother.

"I've met someone and I'm leaving your stupid father," she snapped. "So stop gawking and start carrying this stuff outside, because the taxi will be here in a minute."

That was it, that's all she told us; but without asking questions we did as we had been ordered. We could tell Mother was feeling fractious; any protest on our part would have been not only futile but perilous.

We managed to squash ourselves into the smoke-filled cab. "Where to, Love?" the driver asked Mother as he stumped out his cigarette. I listened intently as Mother told him the address. It wasn't far from our current flat. Soon we arrived at a pre-war, semi-detached house situated in a quiet cul-de-sac.

As we clambered out of the taxi, there standing in the doorway of this house, was our "new" daddy, Ron, a monster of a man standing almost seven feet tall. I later learned that he was an ex-boxer, which explained his bent, misshapen nose and punchy eyes. His light brown hair was thinning on top, and he stank of cigarettes. His hands were gigantic, his fingers dark yellow with nicotine, although they clutched peace offerings of chocolate and sweets. He handed them out to each of us children in a shallow attempt at gaining our trust, and we accepted them politely as we were invited into his house.

Ron was a lorry driver, and had met Mother in the pub where she worked as a barmaid. After a couple of months of endless fornication, Mother, having confused lust for love—and coupled with the fact that she detested Father—decided to move us all into this stranger's house. Ron had insisted that all four of Mother's kids move in with him, as, he said, he was very fond of children.

I felt terribly upset by this whole situation and decided to look around this strange, musty-smelling house while everyone else unpacked their belongings. The living room was sparsely decorated, containing only two heavy armchairs, a couch, a dark oak dresser, and an ancient sideboard overflowing with junk. The open fireplace clearly hadn't been used in years: it was full of cobwebs, dust and soot. The hearth consisted of cracked, cream-colored tiles littered with cigarette butts and half-burnt twists of newspaper clearly once used in an attempt to coax fire from the debris in the hearth. All this was flanked by an old, faded, threadbare Chinese rug.

A set of heavy maroon velvet curtains divided the room in half. When opened, the curtains revealed that the other half of the room was filled from floor to ceiling with junk and clutter:

boxes and bags full of old toys, photographs, documents, hand-written letters and postcards.

I gaped at this treasure trove. I was enthralled at all the amazing objects and photographs of people. The black-and-white images fascinated me. Some of the women and girls wore Victorian dresses; others Charleston attire. I had never seen anything like it before. Among old dolls and teddy bears I came across an old-fashioned wooden marionette. The strings were so entangled I couldn't unknot them, so I just sat the figure on my lap where I could admire her beautifully painted face, faded coral dress and tiny laced boots.

The curtain flew back and an enormous black shape loomed over me: Ron. My whole body jumped in fear, but to my relief Ron said I could play with the marionette; one day I might even be able to keep her. I adopted her on the spot as my constant companion, waiting for the day that she truly belonged to me.

The kitchen of Ron's house was small and basic, with a tiny window overlooking the neglected garden. The room was quite grimy, and didn't have much in the way of cooking utensils. But of course Ron, a cab driver living alone, probably didn't do much cooking.

At the bottom of the stairs, on the sill of a small window, rested a large, ceramic ornament of a fox mounted on a badly-painted grassy hill. The fox had staring, beady glass eyes and an open mouth from which hung a panting pink tongue. I guessed it depicted a hunting scene and I stroked the fox as I made my way up the squeaky staircase.

To the left was the toilet and bathroom. Three other doors led to bedrooms. Mother showed Ann and me to our room; our brothers were to share the second one.

I sat on my bed in a state of disbelief and sorrow. Where

was I? This was not our home; this was a strange man's house. I knew right then that something was very wrong, and not just with the way we had been displaced. I didn't know exactly what the problem was, but I felt it.

Evidence in support of my fears mounted as time passed. To begin with, Mother was not her usual self. Around Ron she acted like a silly, lovesick schoolgirl. For a while she stopped swearing and shouting at us; she actually behaved pleasantly. But we children knew her tricks, knew this show would never last. Mother's foul temper would soon get the better of her and thwart her acting début.

Mother wanted us to be as excited as she was, but I for one felt constantly uneasy and apprehensive about coming to live with a stranger, especially since we had left our father without so much as a goodbye. Nor did I trust Ron. He smiled a lot, but I sensed that his smiles were false.

But he had many ways of trying to win us over. On Friday nights after he finished his last shift of work and got paid, he would bring us lots of sweets. Lining us up, he would ruffle our hair while we took turns accepting his gifts and showing our gratitude. It was a weekly "appreciation" ritual.

Once he gave us each a ten pound note—but then, as our eyes lit up, took the bills back. "I wish I could," he said, "but I can't."

Sometimes he would sit me on his lap for a cuddle. This made me squirm; I didn't like it. But he was most insistent. The harder I tried to wriggle off, the tighter he would hold me.

His breath stank of tobacco and alcohol, his clothes of mothballs. He would stand in front of the cheap, gilded mirror in the lounge and comb back what was left of his hair, slick and shiny with greasy pomades. He had coarse hair all over his body, even on his giant toes and knuckles.

Often he and Mother would go out to get drunk at the pub, leaving us alone in our beds all evening. I would lie there terrified, listening to the creaks and strange noises that filled this most dreary of houses.

One night I awoke to sounds of movement coming from downstairs. I knew that Mother and Ron were out, so I woke my sister. We both crept halfway down the stairs and sat ourselves on one of the steps. We huddled there together, too terrified to go farther as we listened to boxes and furniture being moved around in the room beyond the velvet curtains. As if someone was searching for something back there. We were frozen and cried silently, hugging each other until the noises stopped. No one left the room; the curtain did not move. Finally we made our way back upstairs and got into Ann's bed together to comfort one another.

One afternoon I came home from school and, as usual, hung up my coat and took off my shoes before going upstairs. At the bottom landing I stroked the fox, as I always did, and started up the stairs. Partway up I felt a strong backward jerk at my long hair. I fell backward, grabbed the banister rail and spun around, expecting to see one of my siblings . . . but no one was there. I looked around in confusion and fear. I had definitely felt that someone grabbed my hair. I couldn't have imagined it.

When I told Mother and Ron what had occurred, Ron laughed and said I had probably met the ghost of a little girl who had lived and died in this house. She was jealous, Ron said, because I had taken her favorite toy—her string puppet. The thought terrified me. From then on I lived in constant fear that this ghost girl was watching my every move, planning to hurt or even kill me. But I did not give up the marionette.

One late summer evening, as my brother Nicholas and I were playing at the bottom of the long garden, we noticed that the wooden fence was broken. Deciding to investigate beyond it, we pushed through and entered a jungle of giant sunflowers. We had never seen such gigantic flowers. They towered above our heads, and although the idea of exploring was exciting, I also felt rather apprehensive as we made our way through these amazing giants. We hacked our way forward with just our arms, moving deeper and deeper into what began to seem like an endless field. Above us, the sky began to darken in the gaps between the yellow fringes of flower petals. Nicholas halted, looking around, and I saw the same expression of fear on his face that I felt on my own. We were lost.

Crying, we crashed through the flowers and cried for help. But no one responded, and the farther we ran, the more we panicked. There seemed to be no end to the army of monster flowers around us; if anything, they became thicker and denser the more we ran.

Petrified and screaming, we almost ran headlong into a wall that suddenly materialized before us. A man's head appeared at the top of the wall. "Hey, what's wrong?" We were so distressed we couldn't respond, so he picked each of us up and over the wall into his garden. "Everything's okay," he told us. "You're okay."

But I didn't feel okay. I held my brothers hand all the way home, thinking, *No more exploring for me*. I had certainly learned my lesson, or so I thought.

In those years I was afraid of nearly everything, including school. My teachers seemed hostile and uncaring, and most of the other children unkind and mean. I could never concentrate

on any subject except art. Art was a friend who understood and comforted me; I could always lose myself in the images I produced; the alternate reality that flowed from a secret place deep inside me and out through my crayons and pencils.

But even there I was not encouraged. The alternate reality I drew was not a pretty one. A lot of my drawings were what I can only describe as "creatures": not human entirely, but certainly with human expression, especially the eyes and mouth. They were very expressive and were often crying. I could not cry in reality, so I cried through them. Sometimes the creatures bled through the eyes, nose or mouth, which was completely unsettling to the other children. They called me "Loony," "Weirdo" and "Witch." When Mother saw the pictures she told me "You must be evil to draw things like that." My teachers urged me to draw animals and nice portraits of people. I heeded their suggestions as a balance to what I really wanted to draw but eventually I was made to feel so bad about the "horrible" images that finally I decided to lock my expressive impulses away. When you don't understand what it is you are trying to express, and others around you make you feel ashamed for trying, you quickly abandon the effort, or at least I did.

One Monday morning when I arrived at school early, my teacher looked up from her desk and asked me to go back into the corridor and tell her what time it was, as her watch had broken. I went into the hall and stared desperately at the clock, trying to decipher the meaning of the positions of the hands. I could not tell time. I was terrified that my teacher would punish me for not being able to do so I just stood there, wiping my tears with the sleeve of my school jumper.

I was always crying in school, which really annoyed the teachers. They would ask me "what's wrong with you?" in a

manner so abrupt it would make me cry even more. No one at school ever took me aside in private and asked *why* I cried so much. If they had, I might have revealed the reason for my constant tears: I did all my crying in school because I couldn't cry at home. Mother hated crying just as much as she hated lying; if she caught you doing either, you could expect to be severely punished.

While I vividly remember the terror and beatings, details about everyday life at that age are mostly lost to me. Mealtimes, watching TV, playing with my siblings, illnesses, birthdays . . . are all a blur, a fog. Even Christmases, which conjure pleasant memories for almost everyone, trigger only one memory for me: Mother telling us, on Christmas Eve, "You lot had better not fucking wake me up early."

But if I don't remember the homey details of childhood, I certainly remember the abuse. Especially Mother's embroidery of pain, the tapestry of resentment and hate that took her so many years to create. Some people think it's not possible for very young children to recall traumatic events in detail, or that they confuse facts with the creations of their own imagination. This is utter nonsense. I recollect with absolute precision every blow that crashed down on me. I remember the smells, the colors, the sounds, the pain, the distress; the crying, the sadness, the fear; the shrill voice of my mother screaming at me.

I also remember my own fervent wish: that I could be adopted . . . or had never been born.

I still recall the horror because only the really happy and really bad times stick in your mind. And the bad times stick longest, etched into your memories like the scars of third-degree burns. My only salvation, the only reason I could go on, was

that I possessed a sliver of hope. I don't know where it came from; perhaps it is an innate quality of childhood. In any event, hope is what keeps you going, hope is what keeps you alive. Hope keeps you believing when there *is* nothing else.

I hated my new daddy. Despite his gifts of candy and his ready smiles, there was something false and disgusting about him. I felt an immediate sense of malevolence—there was just something "not right", as though he showed one face but had another hidden behind a mask of smiles and good cheer. He was constantly kissing and fondling mother in front of us—something a decent man surely wouldn't do. I wondered why Mother wanted to be with him; and more, why she wanted him to be near us.

I dreaded bedtime. I hardly ever slept, but lay there crying softly so as not to wake the others as I listened to the noises coming from Ron and Mother's bedroom. Terrible, alien sounds: slapping, moaning, banging, strange sobbing, animal grunts. And above all, male sounds that I had never heard before. I heard Mother begging Ron to stop, because it was hurting; in return he mouthed explicit filth at her. I didn't know exactly what was going on; despite the groping I had experienced in the sheds around my first home, I did not understand what sex was. I simply assumed that Ron was beating my mother. That, I understood.

But all this was about to change. My "new daddy" was about to show me what was really going on in his bedroom at night. In fact, he would show me for the next two years.

You're Such a Good Girl

I was playing in the garden the first time he came and got me. He lifted me by one of my hands as he pried the wooden puppet out of my other hand. In silence he led me into the house. We passed the panting fox. We mounted the stairs. I thought maybe Ron had a present for me. Maybe he had found another toy for me to play with.

But when he took me into the toilet and locked the door, I knew that there was not going to be any present. It was the sheds all over again. Creepy, all over again. Something really bad was about to happen.

As I stiffened with apprehension, Ron raised the toilet seat and unzipped his trousers and pulled out something I had never seen before, even in the sheds. I looked at the floor, my breathing shallow and rapid, as he touched and stroked this thing. To my horror it swelled in size—a giant, veiny, throbbing monster—and he held it next to my little face. My body and mind froze in a species of numbness I would come to know well: the

paralysis of utter repulsion and fear. I stood there, immobile and silent, as he told me to open my mouth. Finally I did.

Although he could force my body to do things to his body, he could not control my mind. My mind didn't have to be there. I could make it leave. I could make it focus elsewhere. So as he told me, "You're such a good girl," and moaned the terrible man noises I had heard so often late at night, I stared at some damp stains on the wallpaper above the toilet. If I focused really, really hard, I could make out images there: faces within the stains. And if I was doing that, I wasn't really with *him* in that stinking little toilet while his monster moved across my face, my hands.

After he zipped up his trousers, he told me that I must never tell anyone about "our games"; this was to be "our special secret." If I *did* tell anyone, well, bad things would happen to me. Very bad things. I already understood this, of course; Creepy had issued the same threats. But now, as then, the commands made no sense to me. Why would I tell anyone? He was only hurting me, after all, even if I didn't know what for, and even if his method was worse even than Mother's. And *how* could I possibly tell anyone? I didn't have the words to describe what had happened. But most importantly, *who* would I tell? Mother? Mother, who let this animal make the same kinds of noises over her every night?

So I said nothing, and "our games" continued. Except that I did not consider them games; I considered them punishments for crimes I didn't remember committing. I was punished on the couch, in Ron and Mother's bedroom, in my bedroom, or in the bathroom, on a regular basis. Ron would put the monster from his pants into my mouth or in my hand; he put his fingers inside me. And every time he did any of these things, my mind became

more and more proficient at escaping my body. As long as there were stains, patterns or shapes on the walls or furnishings, or even in the clouds outside the windows, I was safe. These were the things I frantically searched for whenever Ron took me into a room. Once he led me into his and Mother's bed while it was dark, and didn't turn the light on. As he laid me down, I started to cry.

"Why are you crying?" he asked.

"I can't see the patterns. I have to see the patterns!" I was so distressed that he put on the light.

This method of self-protection, of seeking out images, remains with me to this very day, especially when I lock myself inside a toilet. I automatically seek the shapes of faces within stains and patterns. The habit is so ingrained I'm not usually conscious of doing it. But every now and again the realization hits me, as does another sad truth: Ron was the only person who had ever called me a good girl.

As time went by, New Daddy became more open with his abuse, which at first included my sister as well. One evening, as Ann and I were sharing a bath, Ron came into the room and started talking with us.

We just sat in the tub, trying to cover our private parts, our heads hanging down. Ron grabbed a bar of soap, lathered his huge hands, and began washing my sister's body. She screamed so loudly I had to cover my ears with my hands. Mother ran in and demanded to know what Ron thought he was doing.

He laughed. "I'm only going to wash them."

"They're too old for that," Mother said. Then she shook her head and walked out.

One Sunday morning when I was seven, Ann and I were about to go downstairs when New Daddy summoned us into the master bedroom. Mother was putting on her face at her dressing table mirror while Ron sat naked in bed, smoking, his thinning Brylcreemed hair pressed against the oily black patch on the wallpaper above his pillow. He pulled back the blanket and patted the wrinkled, yellow nylon sheet. "Come and have a morning cuddle."

We obeyed and climbed into the bed like dogs to a master. New Daddy stank of booze, smoke, sex and man-sweat. He put his huge arms around my sister and me and proceeded to reach down and fondle our private parts with his nicotine-stained fingers.

He had never done anything like this in front of Mother before. I stared at her beseechingly in the mirror. After a moment she looked up, frowned, and twisted around in her seat. "Why are you doing that?" she asked Ron. "Leave them alone."

Ron's massive, hairy body shook with laughter that shattered into a smoker's coughing fit. After that passed, he squeezed Ann and me tightly against him. "They like it," he said. "No need to be jealous, love; there's plenty of me to go around."

I searched the reflection of my mother's face for some expression objection, disapproval, anger. She shook her head. "Tut," she said, and continued applying her make-up.

A year later we moved from that house into a ground floor maisonette, or duplex, on an estate near our school. But if the location had changed, daily life remained much the same—except for the ever-mounting tension between Mother and Ron. Both of them were consuming even more alcohol than usual. We children tried to stay out of their way as much as possible.

In this respect, school became a safe haven. Although in my sadness and distress I gave little thought to learning or doing well in my studies, school at least offered a safe haven for a few hours a day. I dreaded the clamour of the afternoon bell, knowing it signalled that I must return home. Knowing what would be awaiting me there.

Children so rarely know when a chapter of their lives—good or bad—is about to end. Our family's final night with New Daddy is an example.

It began ordinarily enough. Ran sat in the armchair with his dinner on his lap and the news on TV. My siblings and I perched around the table close behind him, eating our own meals. Mother was washing up in the kitchen, her upper body visible through the open serving hatch as she jerked about in a foul mood, swearing and ranting as she banged utensils and crockery about on the draining board. Ron seemed to be ignoring her, but every minute his breathing grew heavier, and he began muttering swear words under his breath.

Without warning he swung towards the hatch and shouted in a voice so loud I stopped chewing my food, "Take no notice of the old bag!"

Without hesitation Mother stormed into the room, bright yellow rubber gloves on her hands, the handle of a heavy metal saucepan clenched in one fist. Screaming obscenities, her face contorted into what I can only describe as a Francis Bacon portrait: twisted and contorted. She marched over to Ron and raised the pan high, saliva foaming on her lips as if she had rabies. "Call me an old bag, will you? No one calls me an old bag, you fucking bastard!" And she swung the pan down with all her strength. It struck the top of Ron's balding head with an

indescribable sound and enough force, surely, to explode Ron's skull into a million fragments.

Instead, Ron tried to stand. His dinner plate fell to the floor with a clatter. The armchair tipped over as he groped for the couch. Blood gushed from the gash on his head, spread like roots down his face, and splashed onto his upside-down dinner plate. Like a monster in a film, he stood swaying, gripping the furniture for support, eyes staring through a scarlet mask. I couldn't understand why he wasn't unconscious or dead.

Mother stared at him with an expression of mounting fear and regret.

His glanced toward us children. "Get out of the fucking room," he said, his voice slurred yet calculating. None of us moved. I couldn't move. Ron was going to kill Mother right there in front of us; I was sure of it.

I could see him dismiss us children from his mind as he shifted his gaze to Mother. He straightened his legs. "You fucking crazy bitch," he said, blood spraying from his lips. He wiped it away with his hand, found his balance and lurched toward her.

When he reached her, his giant fists swung in and out, in and out. Mother pled for him to stop, but he didn't. We children stood screaming helplessly. I felt tears streaming hot down my face, and tasted their saltiness in my mouth. Through blurred eyes I watched as Mother crumpled into a heap on the carpet, her voice weakened from continuous begging, just as ours were weakened by pleading with Ron to *please stop hurting her*.

His rage finally sated, Ron straightened, fetched himself a bottle of whiskey, lit a cigarette and collapsed onto the settee. Then he just sat there, staring into space with white eyes in a bloody face, saying not a word. Just smoking and drinking while Mother pulled herself to her feet, clutching a crimson-

soaked handkerchief to her split lips and swollen nose. With agonizing slowness she made her way to bed.

We children also dispersed and got into our own beds, clutching our private thoughts. No one spoke a word.

Eventually I fell asleep, only to be awakened by Mother's hand on my shoulder. "Get up," she whispered. "Get up quickly and get dressed." We obeyed immediately. She said we were leaving; Ron was in a drunken sleep and we had to go *right now!* We followed her through the lounge and sneaked past the huge, snoring hulk, sprawled all over the couch. I was petrified that as we crept past, Ron would open his eyes and reach out like some terrible fairytale ogre.

Outside, we followed Mother through lashing rain to a bus stop. There we waited what seemed like an eternity, constantly checking to see if Ron had woken and followed us. Eventually a bus pulled in. Mother flinched as she pulled herself shakily up onto the steps. The driver stared at Mother's face and asked if she was all right. She nodded as she tried to count out the fare with shaking fingers. The driver shut the doors and slowly drove away.

As we walked down the aisle, all eyes were upon us, especially on Mother's broken face. The other passengers muttered and whispered to each other. Ashamed, I sat down and stared out the window. I just wanted this dreadful night to end.

By the time Mother rang the bus bell and creakily rose from her seat, I knew where we were going: back to our old flat.

Father did not show any emotion as he opened the door and let us in. It had been about two years since we had walked out the door, and just like that he took us all back in. Mother could always control and manipulate him. He gave us all a drink and

told us children to go upstairs to bed while he listened to Mother describe what had happened. I fell asleep with an overwhelming sense of relief: Ron could no longer hurt me.

In the early morning hours I shot out of bed like a spring-loaded trap, trying to comprehend what was happening in the hallway downstairs: terrible noises of breaking glass, shouting, swearing, screaming. My siblings and I ran to the top of the stairs, only to witness in horror the scene at the bottom of the staircase.

The ogre *had* come after us. Ron had smashed the glass window in the front door with his fist to gain entry, and now stood in the house punching Father viciously about the head as Father slipped on the glass fragments in his green-checked slippers. Mother was screaming and trying to drag Ron off.

Just then, through the open doorway hurtled the old Irish lady and her two meathead sons who lived next door. They joined in the melee, fists flying. Ron seemed hardly to notice.

I don't know what possessed me, but I found myself running down the stairs and punching Ron, too, while he punched my father. I had never before felt such anger.

I don't remember any more details about that night. I don't even recall if the police were involved. All I remember was thinking how much I hated my life, and how horrible and evil people truly were. And I had no choice but to live and breathe among them.

And So It Continues . . .

Father forgave Mother—gave her another chance and took us back in.

Everything that had happened to me with Ron got locked away in the darkest corners of my mind. I didn't want to think about it, or even know *what* to think about it. I was just relieved that New Daddy was no longer in the picture. Also, that Mother had decided that she couldn't possibly live in that flat, or indeed that general area, any longer. Realizing that Ron could return any day or night, Mother applied to the council housing authorities for a transfer.

Shortly after my ninth birthday we moved to a new house in a place called Chelmsley Wood. Hearing the name, I imagined nice cottages set amongst pretty woodland. But soon the moving van was driving through one of Birmingham's largest public estates: a clutter of houses, maisonettes and high-rise flats crammed together in a mass of concrete. The "wood" consisted of a few young trees sprouting out of the pavement—those trees

that hadn't been snapped off, that is. There were a few patches of grass around, most of them covered in dog poop, used diapers and rubbish.

Each area was numbered. We were in area thirteen, assigned to a small, three-bedroom shoebox of a house stacked amongst hundreds of other shoeboxes. Each had a small, square garden in the front, and another in back containing a tiny brick shed.

As we were unloading our things from the van, I saw curtains twitching in neighboring houses. Some people even stepped outside to watch us moving in. This made me most uncomfortable but thrust Mother directly into anger. Sticking her fingers up to the watchers, she shouted, "Nosey bastards!"

As I entered the lounge to unpack some of Mother's ornaments, I stared around in revulsion at the chocolate brown and orange patterns of the wallpaper. The bright orange fiberglass curtains irritated my skin when I touched them. On one wall hung an enormous framed print of a stag standing proud in a Scottish glen. On the opposite wall hung a print of the horrendous Green Goddess, a woman with black hair and green skin. I laid a black-and-white goatskin rug down in front of a fake coal fire. Mother's prized possession, the rug had taken her a year to pay for in installments.

Inside the council-standard, white-laminated kitchen, Mother unpacked her precious Pyrex, Tupperware and Melamine products as men carried in her newly acquired twin-tub washing machine. I stared at the washer in astonishment: it was a far cry from the sink, washboard and wringer we used to have. There were also two other modern amenities to enjoy: central heating and a telephone, things we had never had before.

As usual, Ann and I shared one bedroom, and our brothers another—and also as usual, the boys complained that their

room was smaller. "That's because girls always have more stuff than boys," Mother said.

After much unpacking, we were told to go outdoors. It didn't take much looking around for us to discover that whatever improvements our new home might have, we were still living in council housing in a council neighborhood. Some of the surrounding flats had police stations on the ground floor so the officers could be right where the action was. The row of local shops nearby hunched behind graffiti-covered metal shutters. At lunchtime, work-shy alcoholics fell out of the local pubs and queued at a local chip shop to get pie and chips, which they would take home and eat before collapsing on their couches and sleeping it off until the pubs reopened.

Vortexes of litter swirled around like mini tornados, brushing the bare legs of swearing, smoking, pregnant mothers maneuvering pushchairs stuffed with half-clothed infants. The women stopped to congregate and gossip about their neighbors and friends, cackling like modern-day Macbeth witches. In passing I overheard one older mother advising her young pregnant daughter to smoke a lot more, because "It's easier to give birth to a small baby." Gangs of obnoxious children sat on vandalized benches smoking and drinking cheap lager while shouting abuse at elderly passers-by.

On the day we arrived my siblings and I were exploring the alleyways, communal gardens, sheds and washing areas in our neighborhood when a group of children surrounded us to "Check out the new kids." A big, ugly girl marched straight up to me and, without a word or a reason, slapped my face as hard as she could. I ran home crying. As usual Mother shouted at me for "not hitting back." But I couldn't hit back. I just wasn't the aggressive type. I hated violence.

I went out back by the shed where we had installed a large hutch containing my pet rabbit. Climbing into the hutch, I sat stroking and talking to the rabbit for the rest of the day and thinking about my most unpleasant welcome to the neighborhood . . . and dreading the thought of going to school on Monday morning.

As I had feared and expected, my new school proved to be a microcosm of my new town. As I approached the building I saw dozens of mini-delinquents running amok in the playground, fighting, swearing and vandalizing school property without interference from a clutch of teachers standing helpless near the front entrance.

Inside, things were just as bad: endless chaos punctuated by playground fights, property damage and half-hearted physical discipline. In the midst of this anarchy I would simply withdraw into my own world, while on the outside remaining quiet and passive to everyone around me. My inner world was a wonderful place where no one hurt anyone else and everyone was happy.

Other kids chose a different escape route. Many of them were already on drugs—at only nine or ten years of age. Those who couldn't get their hands on the "real stuff" tried just about anything to get high. They sniffed glue and other toxic chemicals like cassette-tape cleaner or drain-cleaning fluid. They stole prescription drugs from their parents or grandparents. One boy I knew swallowed malaria tablets by the dozen.

Not that it mattered; escape of any kind was only temporary, something we were never allowed to forget. At school, a typical "career trip" consisted of looking around a sanitary wear factory. That was it. That was the future we were taught to

anticipate, the most we were ever expected to attain. Personally, I loathed the thought of such a "career," but my feelings about it meant nothing—even to me. What were my alternatives?

My mother had recently changed jobs. From barmaid she had become a "care mother" in a local children's home, which required her to spend many nights and weekends away from her own family. That was how I, at the age of eleven, became responsible for running our household: doing virtually all the cooking, cleaning, washing and shopping. Shopping alone meant walking a half mile to the grocery store and back again carrying bags so heavy I had to stop every few minutes and put them on the ground to give my arms a rest.

But that was only part of the irony of my mother being a "care mother." When she came home I would often overhear her ranting to my father about one "little bugger" who wiped his own excrement on the toilet wall. Mother became increasingly angry with this child, swearing that she would "sort him out."

At least she was consistent. On the night of October 31st— Halloween—there was a loud and purposeful knock at our front door. Mother opened it to my younger brother Nicholas, flanked by two uniformed police officers. One of the policemen explained that Nicholas and some other boys had been caught throwing raw eggs at old people's windows and scaring them. Mother apologized and assured them that her boy would not be doing that again; she would teach him a lesson. Satisfied, they said goodnight and left.

Mother softly closed the door and turned towards Nicholas. "Get upstairs, get washed and get into bed," she growled, the expression on her face darker than I had ever seen it before, even the night she struck Ron with the frying pan. I sensed that

something *really* bad was about to happen, so I crept up the stairs toward my bedroom. Before I could close the door I saw Mother marching heavily up the stairs, a black stiletto-heeled shoe clutched in one hand. Nicholas didn't see her. He had pulled off his jumper and had just begun washing in the sink.

"*You bring police to my fucking door?*" Mother bellowed, and hammered the heel of the shoe into his head. "*You little piece of shit! You fucking bastard!*" The heel slamming down again and again.

I cried, "Mom . . . don't!"

But she was out of control, the shoe rising and falling. I wanted to stop her, but knew that she would simply direct her anger at me. So I watched in helpless horror as my little nine-year-old brother hunched under the sink, trying to protect his head with his hands

"*Bastard! Bastard! Bastard!*" Mother chanted with each blow.

Suddenly she stopped. Not because she realized what she was doing, but because the stiletto heel had gotten stuck underneath Nicholas's scalp. She finally yanked it out and told my brother to clean himself up and get to fucking bed before she killed him. Then, still clutching the shoe fiercely, she turned towards me. As I stared at the blood-smeared heel she shouted, "And *you!* Nosey fucking bitch, you get to bed too!"

I did as I was told. I lay in my bed, hugging my pillow tight, with huge tears in my eyes for Nicholas . . . and hate in my heart for Mother.

6

Sex, Drugs, Alcohol . . . and Another New Daddy

It was the spring of 1972 when Father left—or, more accurately, was thrown out. Mother told him a "real" man, Mark, was coming to live with us. So here we were again: Mother had fallen in love with another complete stranger—a guy she had met in the local pub—whom we all had to live with.

I passed Father on the stairs as he was carrying his suitcases and some boxes to the car. I wanted to say something to him—anything—but no words came. There was no real love or emotion between us. I just felt sorry for him, and wondered where he would go, and what he would do. That was all.

On the weekend Mark moved in, he took us all to the zoo. Although only in his early twenties, Mark looked and seemed a lot older. He was a rather jolly, stocky, bearded man who reminded me of what a young Santa Claus might look like— but of course I was far too cynical to trust him. He and Mother couldn't keep their hands off each other during the drive to the zoo. She kept squeezing his privates and giggling. As I listened

to them "carrying on," I stared out of the window and thought, *No way can this man be normal.*

Mark and Mother had sex day and night. Their headboard hammered the walls and their grunts and moans reverberated throughout the house, regardless of who happened to be home at the time. Often they would sit in the lounge watching *Coronation Street* or listening to the Moody Blues on Mark's new Dynatron stereo record player (which we children were forbidden to touch). I was always thrilled when dinner was over and I could go out for the rest of the night and not have to listen to them having sex or smooching on the couch.

One day while I was alone at home, I decided to go through Mark's belongings. I wanted to know what kind of man he was. I went into their bedroom and searched through his unpacked suitcases. To my horror I discovered pornographic material that filled me with repulsion and disgust: women and men having sex with animals, fornication and fellatio involving horses, cows, sheep and dogs. Although I quickly put the magazines back, I could not erase the horrific images from my mind. Mark never abused me in any way, but knowing what he enjoyed looking at always made me feel wary and uncomfortable about him.

After the summer holidays ended, I was set to start studying at a secondary school that happened to have the worst reputation in the area, even though it boasted the most expensive, modern facilities: a swimming pool, athletics track, gym, music rooms, science laboratories, art studios and a fantastic theatre. But it was all pointless and futile, for the school contained not only the most disruptive and dysfunctional of kids all in one contemptible clump but also numerous teachers willing to take advantage of these defective and abused children by selling

them drugs or extending the abuse they suffered at home into the school yard.

For me, life at that school was full of fear and trepidation. Not a single day passed without incident, or a lesson without utter disruption. Drugs and alcohol were consumed daily, and violence was inevitable. One boy defied a teacher by shouting, swearing and jumping out the second floor classroom window because the teacher had blocked the door to keep him from leaving. Another boy broke the Religious Education teacher's nose as the teacher was trying to wrestle the lad out of the room for disrupting class. Even the headmaster was attacked. He wore hard contact lenses and on one occasion was repeatedly and purposefully punched in the eyes, which left him with a permanent squint. Many student teachers who came there did not last long—understandably.

Graffiti and vandalism were rife. Fire alarms went off all day, every day and the toilets were regularly flooded. One morning we came to school to find that someone had blown up the gigantic water tank that stood next to the swimming pool. I don't know how they did it, but they did. Not that people were able to use the pool much, anyway, because it was constantly sabotaged by broken glass.

So for me, the most important lesson I took away was: "How to Survive School." I never thought about a career, or even a future. I simply contended with each hour of my life. I often wished that I was in a good school because there was so much I wanted to know. On the occasions that I could watch television, I would see programs about talented people who could play the piano, or learned people who could read Latin or recite Shakespeare. I would have loved to be able to do these things. What a luxury it would have been to read all the classic novels or even

act in a play. I would lose myself in this beautiful fantasy—and then come crashing down to my harsh and ugly reality. These were unobtainable dreams in my lower-class world that I could never tell anyone about; I would have been ridiculed, mocked and excluded. This was simply how things were, a way of life. All I could do was to try to get through each day intact. Try to smile, maybe laugh a little, and whenever possible find some good in people.

The one truly decent person in my life at the time was one of my art teachers. She was kind, even-tempered and took a real interest in my work, encouraging me and offering constructive advice. Peering over my shoulder as I worked on a project early on in her class she said, "You are extremely imaginative and so good at art." That one small sentence buoyed my spirits for the rest of the day. No one ever complimented me. It meant so much. I used to look forward to her classes, and would try and do my best to please her, to be rewarded with the praise I so needed.

Art class was a total escape from the real world—in a good, constructive way. To make my art realistic I needed intense concentration. This, along with my imagination, took me far away from the pain and stress of everyday life. While drawing, I became nearly oblivious to the world around me. In fact, I preferred the challenge of drawing from my mind. I didn't like to just copy things; I wanted to create images that people had never seen before—like Salvador Dali's work. It was extremely exciting and made getting up in the morning easier.

Unfortunately not all the teachers were like her. Many just contributed to the troubles at the school. Some teachers, mainly from the art block, lived close to the school and would often have wild parties. Although kids were not allowed to those, the teachers would happily sell drugs to students who knocked on

their doors. Some of the teachers were lecherous creeps who made constant sexual advances to the girls in the school. One afternoon an art teacher cornered me in a studio while I was collecting some work. He pinned me a wall and began kissing and groping me. I could smell the alcohol on his breath as he begged me to meet him later that night in secret. I punched him and ran like hell.

I didn't learn much about art from him, either. His classes were every bit as chaotic as any other, and his version of "teaching" consisted of writing the title of a poem or song on the board and letting us "interpret" it.

There was often a police presence at the school, but one particular Monday morning dozens of police officers busied themselves around the Technology block, which they had sealed off with police tape. We learned that Mr. Brown, the Head of Technology, had been having sexual liaisons with a fifteen-year-old student—and had strangled her to death. I was shocked. I had been attending a weekly evening design club run by Mr. Brown and had thought him a most caring teacher who took active, constructive interest in his students.

There were genuinely good teachers at the school, too, and I felt sorry for them, as well as for the nice kids who were the object of so much taunting, bullying and humiliation. But there was nothing I could do for any of them. If I dared intervene or protest against the cruelty in any way I, too, would have been tormented. So I pretended to be unaffected—I was just an actor in a horrible movie—a movie I detested.

Later, when I spent two weeks carrying out work experience in a mental asylum, I found the place pretty conventional compared to the insanity of my school.

By the age of thirteen I had accumulated a particular view of even the best of men: they were creatures driven by sexual lusts they would do anything to satiate. Yet, inexplicably, I also felt the need to attract them.

That part was easy. By this time I had developed physically and was considered extremely pretty, so many men took a sexual interest in me. I let them fulfill their desires, even if I didn't like them, far less want to have sex with them, and even though I knew I would feel degraded afterwards. I usually met them at pubs, or sometimes at parties, and they were usually quite a bit older than me—anywhere from eighteen to twenty-three.

Looking back, I realize that it wasn't sex I was interested in. I was hoping to find a man who would hold me and show me something I had never known before: love. It was a most confusing time for me and somewhat difficult to explain to people who have not been abused. On one hand, my mind closed down if a man started to have sex with me. I would just let him do what he wanted because I always had. On the other, hand, I enjoyed the part of being held and wanted. It was a substitute for love, something that I had never felt, certainly not from my mother who never held or hugged me. When I gave myself to a man and felt his arms around me, I could persuade myself that he wanted and valued me as a person—an individual worthy of love.

Being so yielding and submissive made me ripe for predators, of course, and during the next couple of years many men took advantage of me, even those I should have been able to trust. My best friend, for instance, had an older brother. His mother

insisted that he walk me home in the evenings to make sure I got home safely. In reality, he was the one to be feared—he would force himself on me as soon as we got to a secluded spot where he wouldn't be caught. I tried to push him away but it only excited him. Not surprisingly, years later I learned he was in prison for rape.

Most of the men who used me for their own gratification were strangers who gave me alcohol at pubs and parties and then took advantage of me. I was a willing victim. I never resisted or fought back because, like most severely abused people, I accepted abuse as the norm; it was all that I knew and all that I was. Being abused felt safe, predictable. It was happiness and kindness that were not to be trusted. Anybody who *was* kind was usually just doing so because they wanted something from me.

In a sense I actually sought for a continuous stream of bad things to happen to me, because if something good were to occur, I knew I would pay dearly for it. It sounds counterintuitive but this is the mindset of being constantly abused. The horror of abuse is safe because you know it well, it is your lifestyle. You actually feel that you deserve it because often you are blamed for the sexual abuse. It's all your fault "because you are too pretty"; or you deserved to be hurt because "you are naughty or provoked the attack." Since you survive it each time, you are still okay, still alive. You believe that any happiness that comes your way is undeserved and you will pay dearly for accepting it, and it will be followed by something more devastating or more hurtful than your daily abuse. As the saying goes, "better the devil you know . . . "

My chosen behavior had its own price. I came to be called a "slag" and a "whore" by other girls, on the streets or in school;

a girl who was "easy." I hated being classified as any of those, so my quest became to find a "regular" boyfriend.

One night I brought home a twenty-three-year-old man I had met in a pub. (While today licensed proprietors would be administered hefty fines for serving underage people, in those days, they didn't care about who they served. Besides it was usually the older guys who bought my drinks while I was sitting away from the bar.) We swung by the house so I could pick up some of my things before going to a party. Mother whispered to me that she "fancied" him—not, as a nice date for me, of course, but meaning that she wanted him for herself. When I told her his age, she muttered that he seemed a little old for me. I was thirteen; of course he was too old for me! He was a bloody pedophile. Not that I knew what a pedophile was back then; I had never even heard the word.

One afternoon Mother came into my bedroom and asked, "How do you wank a man off?" I laughed and shrugged her question off, saying that I had no idea. But I wanted to scream, *"Why didn't you ever ask your last boyfriend? He's the one who taught me!"*

In addition to dating grown men, I frequently went out to all-night parties. It was at one of these parties that I met my first serious boyfriend, Paul. He was almost eighteen, a decent, kind and humorous guy who made me laugh a lot. He was very tall, with long brown hair and the eyes of a doe, complete with curling lashes. He wore unwashed, holey jeans and a long Afghan coat that smelled like a wet dog.

I began dressing like a hippie, too, and going out regularly with Paul and his friends. Sometimes we would all attend a movie or concert; other times we would just chill out at Paul's house. We saw amazing bands like Led Zeppelin, David Bowie

and Queen. For me it was a relief to have a life outside my house, my school, or the streets. I could never have afforded tickets myself for shows like this but Paul had a part-time job and lived with his parents so he had plenty of spending money.

One night, Paul and I missed the last bus home from a party we had gone to and had to walk home. We got to my house very late. I knocked on the front door and held my breath as I heard Mother's footsteps thundering down the stairs. While she typically didn't care where I was or how late I was out, I had told her that I would be home earlier, before she went to bed. Now we were late and as luck would have it I had forgotten my door key. She was furious only because I had woken her up. The door flew open and, before we could even begin to explain why we were so late, Mother screamed in Paul's face: *"Fuck off!"*

She pulled me inside, slammed the door, and proceeded to drag me to the top of the stairs by my long hair, punching or kicking me every step of the way.

Later, I lay in bed with my head spinning and my scalp throbbing from the beating, crying with humiliation and anger. I imagined leaving home and running away with Paul. I don't know what he thought of this episode. He didn't come to my house very often and when he did it was just for a moment. I had never talked to him about my home life or the beatings. He had no idea about my hellish existence.

As a regular at parties and clubs, inevitably I discovered alcohol and drugs. Actually, by then I had already been drinking quite a lot, often from bottles stolen from friend's houses. Alcohol enabled me to blot out the pain and sadness that engulfed me and to sink into wonderful oblivion.

One night when I went to a club with friends, I drank so much

that the whole room began to spin. Although I could barely walk, I somehow made it to the toilets, where I collapsed onto the filthy, piss-covered floor. I didn't know whether to urinate, vomit or pass out completely. In that bleak moment I felt that I was actually going to die—and I embraced the idea entirely.

I was fourteen years old when I decided to try LSD for the first time. I had been observing those under its influence at parties, and had read up on drugs at my local library in order to find out which ones were most addictive, and which caused organ or brain damage. I decided that LSD was for me. From what I had seen and read, the effects seemed to be worth the risks. If I died, then I died.

Although I didn't know it at the time, what I received at the next party was not LSD but another synthetic hallucinogenic called STP, which produces a stronger and much longer-lasting high. I took a dose on Saturday night and was still tripping not only on Sunday but also Monday at school. The Sunday was the hardest to get through, though, because Mother was away all weekend working at the children's home, which meant I had to do all the cleaning and cooking. She had left strict instructions about my chores, and as I tried to read them, the letters started waltzing on the page. When I looked at the clock the hands flew off, and when I tried to find some pork in the freezer, all the joints of meat had turned into human limbs. When I tried to make the gravy, it turned into a molten volcano that grew so big it filled the entire kitchen and drove me out.

I could no longer determine what was real, and the more I attempted to reason with myself, the worse the visions became. I tried to cook Sunday lunch, but it was impossible; by then I was hallucinating so hard I could not function at all, so I feigned

sickness. Mother's boyfriend, Mark, came and took over. He told me to go to bed; he would handle everything.

As I lay on my bed, I was at first overwhelmed. Then I found myself transported, mesmerized by music, patterns, orgasmic sensations and funny, crazy, beautiful visions—and I felt an incredible feeling of peace surge through me. A feeling of bliss, joy, meaning and solace. For the first time in my life I felt truly happy; perhaps even ecstatic. I wanted to do this again and again.

This drug would provide me with a respite from all the horrid days and all the horrid people—STP was far better than alcohol; it offered the epitome of escapism.

Leaving Home

On a freezing-cold morning in February 1976, at the age of fifteen, I left the career guidance office with a sinking heart and an unpleasant feeling of humiliation. The advisor had laughed in my face when I suggested to him that I would very much like to attend an art college. In the U.K. students leave secondary school at sixteen and then go to college, which is similar to the last few years of high school in the U.S. A university education happens when you are eighteen. I had tried to make it clear that art was the only thing that I was good at, the only thing that gave me any sense of purpose. He had told me take my head out of the clouds and get a "real" job. He suggested the options offered to most girls at that time: nursing or home management.

When I told Mother what the advisor had said, she agreed with him. "Art college, my arse! What, you think you're something special? You can't get a normal job like the rest of us?"

Not confident enough to believe in my own convictions, I believed what they both told me. I arranged to start a two-year

course in home management, which is like home economics in the United States. Since all my college fees and travel expenses would be paid for by the state Mother didn't object to my going.

But even if I would not be attending art school, I could still draw at home, for my own pleasure. It was around this time that I began to produce my first really disturbing images— images drawn from the depths of my own mind. Even more than the pictures I drew as a child, these works were dark and disturbing: screaming faces, heads studded with knives, insane demons, monsters.

I quickly learned to hide this kind of work from others because once again it earned me nicknames like "Satanist," "Witch" and "Loony." If I drew animals and film stars, people always thought the work was really good, and admired my self-taught technique. Yet animals and film stars were not what I *wanted* to draw. What I wanted to draw were those other, darker things, the things that made people think I was crazy. So perhaps my critics were right; perhaps I was insane. I started to read books and articles about and by other people obsessed with dark ideas: horror stories, detective stories and true crime tales. I read about the Mafia, serial killers, and psychiatric case studies of self-harm and mutilation. I read and watched documentaries about the Holocaust.

I found comfort in these horrendous stories. They reminded me that no matter how bad my life was, others had suffered, or were suffering, worse. They helped me put my life in perspective.

Late one evening while I was reading in bed, a dreadful commotion erupted from the kitchen. I climbed out of bed and pressed my ear against the central heating vent in my bedroom. Mother and Mark had returned from the local pub and I could

hear Mother swearing and shouting in a slurred voice, accusing Mark of flirting with a blonde woman.

Mark laughed. "Don't be so bloody stupid, woman!"

"Don't call me stupid, you bastard. All men are lying, cheating bastards!"

"I wasn't flirting; you're just drunk; why don't you go to bed?"

"Don't tell me to go to fucking bed, this is my house and I'm not fucking drunk!"

A loud scuffle ensued, and a minute later I heard Mark say, "Put the knife down! Put the knife down!" His voice dropped into a lower register. "Come on, sweetheart, please put it down; you don't really want to hurt your teddy bear, do you?"

To my relief, I heard Mother crying and Mark comforting her. They then walked slowly up the stairs and into the bedroom, where they soon engaged in noisy "make-up" sex. And so, with the knowledge that they were still both alive—but very much wishing I possessed ear plugs—I went back to bed.

Love and violence, violence and love. In my world they were so intertwined it was often difficult to tell them apart. My sister Ann had a boyfriend named Martin she met at a party when she was fourteen and he was seventeen. He was a greasy, long-haired stoner type with a peaceful, laid-back hippy vibe. Everyone liked Martin. Everyone except Ann—she loved him completely.

Still, one evening after she returned from a night out with Martin, and as she took off her jeans, I noticed a massive, dark purple bruise on her upper thigh. "How the hell did you get that?" I asked.

"Oh, Martin did it. But it was my own fault, as I provoked

him." She said it quite nonchalantly. When your own Mother beat you black and blue, what was the big deal if your boyfriend did so as well?

Ann had a violent streak of her own. She was loud and abrasive and had a terrible temper, while I was the quiet one. Although I tried to stand my ground against her, she would always beat me in a fight, her strength fueled by her anger. I was never able to conjure up that sort of fury. It just didn't seem to be within me. Or so I thought.

But one afternoon after school, I was peeling potatoes at the kitchen sink, trying to stay out of everyone's way because I was feeling extremely irritable. Ever since I'd started menstruating the previous year I had experienced extreme mood changes every month. Or perhaps my newfound emotions had something to do with the contraceptive pills I had started taking the moment my periods began. I never wanted to get pregnant.

I cannot remember exactly what Ann decided to tease me about that day, but she came into the kitchen and began trying to provoke me. I put up with it for a while, then without warning spun toward her and tried to plunge the potato-peeling knife into her chest. Her hands shot up and the blade sank into one of her fingers. She screamed so loudly that it jolted me into the realization of what I had done even as it brought Mother hurtling into the kitchen.

"She stabbed me!" Ann blurted, clenching her hand as blood pattered to the floor.

I stood there in shock; it was as if another person had stabbed my sister, not I. Surely I was not capable of such a thing.

And then the fear hit me: the fear that I was about to get the beating of my life from Mother. I awaited my doom as she

bandaged Ann's finger. But when she looked up at me, she was smiling. "At last," she said, "you finally have some spirit."

Although I was relieved that she was not going to punish me, what I mostly felt was terrible disappointment in myself. I had always maintained that I would *never* become Mother— yet here I was, behaving just like her...and for the first time in my life, I had made her proud of me. I would have preferred a beating.

Soon after that incident, when she was seventeen, Ann left home to live with Martin. I was jealous that my sister had gotten out, but I knew my turn would come soon. But first I had another incident with the knife.

Again it began with me standing at the kitchen after school, peeling potatoes. And again I was in one of those dark, irritable moods. But this time it was not Ann but Mother who stood behind me, provoking me. She jabbed at me with her strong, bony fingers, calling me lazy and spoiled and complaining about the clothes strewn about my bedroom.

"Shall I chuck all your clothes into the fucking bin?" she demanded, emphasizing each word with another prod in the back. "*Shall I? Shall I?*"

Without thought I turned around and faced her. "*Yes!*" I shouted into her face.

The look she gave me was a combination of horror and disbelief...followed by fury blacker than any I had seen there before. I thought, *Oh my God, get away quick, run!* But as I began to turn, Mother grabbed my hair, pulled me to the floor and dragged me to the sink.

"*You fucking talk to me like that? I'll show you, you fucking bitch!*" she screamed as she reached for the paring knife.

I stared up in horror, knowing that I could very well die right there, right then.

But as she took hold of the knife, adrenalin surged through my body and I leaped up, grabbed her arm and twisted it so hard she dropped the knife. Then I bolted for the door. She hurled empty glass milk bottles at me, and they shattered on the floor and walls like bombs. I was wearing only a short, skimpy dress; my legs and feet were bare. Shards of glass pierced my calves and cut my feet as I banged the door open and bolted into the dark, wet streets.

When I could run no farther I took shelter from the driving rain on the bottom step of a block of flats. Crimson blood streamed down my legs and over my freezing blue feet. I hugged my knees. "She's fucking mental," I sobbed. "She's fucking mental . . . " I didn't know what to do. I wanted to run away, but I had no clothes, no money and no one to turn to. My only option was to go back and face her.

As I quietly opened the back door of the house she leaped off the sofa, shouting, "*Where the fuck have you been? Don't you ever answer me back again, do you hear?*"

With her hand she whacked me around the head and ears, sending vibrating noises through my skull. She hadn't calmed down a bit in all the time I was gone. When she'd finally worn out her arms, she ordered me to go to my room. I sat on the end of my bed and clung to the comfort of the thought that my sixteenth birthday was approaching, and when it arrived, I would be out of this house forever.

Then Mother opened my bedroom door and sat down next to me. My skin crawled as she pushed my hair behind my throbbing ear and asked me if I had told anyone about what had happened earlier. "No," I said. "I haven't seen anyone or told anyone."

"Good girl." She got up, ruffled my hair and smiled. "Go on and have a nice bath, and make sure to wear trousers tomorrow instead of a skirt."

The morning of my sixteenth birthday finally arrived. It was a Saturday, and as I got dressed, I wondered if my mother had remembered. She and Mark were still in bed. My belief that she had forgotten was confirmed when I heard her send my younger brother to the local shop to buy a birthday card for me. Later that morning Mother appeared in my bedroom with the card, a present and a smile. I unwrapped the package. It contained a small, tatty jewelry box, inside of which rested a cheap engagement ring with some of its stones missing and the rest cloudy. I looked at Mother, puzzled.

She told me that Ron had given the ring to her, and now I could have it. So, for my sixteenth birthday, my mother was giving me a ring owned by the man who had sexually abused me in our own home. Was this some kind of sick joke? Was she rubbing salt into my wounds?

"Happy Birthday!" she said, and left me alone, holding the abhorrent memento.

A few months later, during the waning days of summer in September 1976, I finally left home. Mother didn't attempt to persuade me otherwise; I'm sure she was relieved to have one less mouth to feed, not to mention an empty bedroom to offer one of my brothers.

Paul had been quarrelling a lot with his parents and also wanted to leave home. We decided to make the decision to

move in together and be free from parental disharmony and control. I was attending college but Paul had a job that paid just enough for us to rent a cheap flat. It was above a hardware shop, nestled amongst a long row of shops near the city center. The flat was in a dreadful state, with a single damp bedroom overlooking the noisy main street. In winter you could see your breath even inside the flat, and the curtains were frozen solid.

The tiny kitchen measured about six feet by four. It contained a shower, which never did more than dribble, so I had to bathe myself in a plastic washing-up bowl. Sometimes while I was cooking, rats would dart in between the cupboards, so I always made sure I wore shoes in the flat. The lounge had no windows save for a small pane of glass set in the outside door that opened on a set of metal steps leading to an outdoor toilet. The toilet was used by just about everybody—people like the "dustbin men", postmen and delivery men who delivered to the shops beneath us. We had to use this even in the winter months when the water and urine froze solid in the bowl.

What with rent, food, electricity, and Paul's traveling expenses to work, he and I could barely afford to pay for these luxurious accommodations. We were always cold and hungry. In those days, if you had a job, you could not claim any government assistance and even today there is no such thing as "food stamps" in the U.K. Most evenings after the shops closed for the day, I would take plastic bags and go "shopping" in the dustbins. After collecting any food that didn't smell too horrid, even if it displayed mold or rot, I would scrape the bad parts clean and eat what was left—a terrible thing to have to do, but it meant that we wouldn't starve, that we could exist here together. And above all, it meant that I didn't have to go back to *her*.

Another problem was cigarettes. I had been smoking since I was eleven, and now could not get through a day without one. I would have preferred to go without eating. But tobacco was expensive, so many nights I would resort to collecting cigarette ends from pub ashtrays, bins and floors to roll my own cigarettes. I didn't care about the looks people gave me.

I also stole toilet paper and small bars of soap from pub toilets. I felt really bad for doing that, but I was living the truism that desperate times call for desperate measures.

Paul and I were constantly one small step from being out on the streets. It was a daily struggle; hard and desperate times— but preferable to living with Mother.

A few months after leaving home I quit college. For one thing I hated the course; but that wasn't the biggest problem. I simply could not afford the bus fare and meals. My travel expenses had been paid for by the government only so long as I was a dependent child living at home, which I was happy to no longer be.

But staying at the flat was not a joy either. Paul had a small motorbike, and when he wasn't working he usually rode off to visit family and friends, leaving me alone—and lonely. I would often go down into the hardware store underneath the flat for chat with the landlord and his son Jeffrey, who also worked there. I had gotten to know the guys and they would make me coffee and offer me cigarettes. It was nice to have some company—not to mention a free, warm drink.

One day Jeffrey showed me an advertisement in a popular photography magazine seeking young models to work in London "for exceptional pay." The advertisement had been placed by a modeling agency that was interviewing girls all over the U.K. Jeffrey said, "You should give it a go. You're really pretty

and could make a lot of money." He tore out the advertisement and gave it to me. I filled in the application, included a photograph of myself, and sent it off. Exceptional pay! It was difficult to imagine such a thing. How it would change my life.

I gave no thought to the legitimacy of the ad or the modeling agency. Surely such a reputable magazine would not allow anyone dodgy to advertise in its pages.

A week later I received a reply from the agency: they thought I had the kind of face and figure they were looking for. Could we arrange an interview as soon as possible? I whooped for joy.

Little did I know that in another week's time this dream come true would turn into a nightmare worse than any I had ever imagined.

The Divine Tragedy

I was so excited on the morning of my interview. I had an appointment to meet Mr. Black, the modeling agency's manager, at an exclusive hotel in the Birmingham city center at two o'clock. I washed my hair, carefully applied my make-up, painted my nails, put on my prettiest dress, and climbed onto the bus. I felt terribly nervous as I walked into the hotel lobby, but I needn't have been, because Mr. Black was most charming. A small, thin man in his late fifties or early sixties, he put me to ease straight away, and after a couple of drinks and a long chat, handed me a contract and a consent form for one of my parents to fill in and sign, as I was only sixteen and still a minor. This served to validate my belief that everything we were doing was above board and bona fide. We discussed the traveling arrangements for the following week, and then said our goodbyes on a handshake.

I almost skipped back to the bus stop. Once in my seat, I went over the things that he had said to me. He had told me that I had the most symmetrical face that he had ever seen, that

I was incredibly photogenic and that he had "big plans" for me. I had never in my life been so thrilled.

Back in Chelmsley Wood, I went straight to Mother's house to ask her to sign the consent form. I suppose I could have had Paul forge her signature and skip seeing her altogether, but it really didn't enter my mind since Mr. Black said a parent had to sign it.

My visit with her was short and relatively painless. She asked only a single question: "Where did you see the advertisement?"

After I told her, she signed the form and we said our good-byes. "Have a good time in London," she said.

The following week, I met Mr. Black at New Street railway station. I was beside myself with excitement, especially as I had never been to London before. I felt so confident and flattered as Mr. Black complimented me on my appearance and told me about all the jobs he would line up for me, both in London and on the continent.

We arrived at Euston Station late in the afternoon. Mr. Black flagged down a cab, and told me that he had a surprise for me. I was amazed as I took in some of the famous sights during the ride: Big Ben, Madame Tussaud's, the Natural History Museum and Tower Bridge. My excitement grew when he took me into an exclusive shop to pick out an outfit. He told me that he wanted me to look "really special," as we were to meet his partner for dinner and drinks that evening. I was thrilled as I stepped out of the changing room wearing a sophisticated cocktail dress, silk stockings and high heels. Mr. Black paid for my new outfit and shoes, and asked the shop assistant if I could wear them out of the store, and if she would kindly put my clothes into a carrier bag for me.

At 7 P.M. we walked into a top restaurant to meet Mr. Black's partner Mr. Smith. He was a tall, blond-haired man of equal charm and courtesy. We drank, ate, and discussed my promising future until around 11 P.M., when the three of us climbed into a cab. I assumed we would be going to a hotel where we would say our good nights, so I was surprised when the taxi came to a halt on a nondescript little side street. We got out and the two partners escorted me on foot through increasingly dark and seedy streets. They made idle small talk but their voices became muffled in my mind as my sense of apprehension grew. My mind raced but I never asked where we were going; I guess I was still thinking—or hoping—that we were just going to a regular hotel. As we turned one dark corner after the next, my feeling grew worse and, with no money, nor any idea of where I was, so did my awareness that I couldn't simply turn back.

Finally we reached a large Victorian building that looked as if it had once been a hotel, but now many of its windows were boarded up, and it was in a terrible state of disrepair. Mr. Black unlocked the heavy front door and escorted me into a bar area in which a few shifty men sat drinking and talking. They all stopped simultaneously to stare at me as we entered the room.

"Sit down," Mr. Black said in a voice far less affable than the one he'd used all day.

Mr. Smith walked up with some drinks and a smile. "Just a nightcap for you, darlin'."

As I finished my drink, Mr. Black turned to me and asked, "Would you mind coming to my room to sign some papers before you go to bed?"

"Okay," I said, although alarm bells rang frantically inside my head.

As we walked down a hallway Mr. Black pointed to a door

and said, "That's your room," but we continued on to another door, which he opened. Inside, he gestured for me to sit on the bed while he crossed to his briefcase and a pile of paperwork on the dressing table. That was reassuring. As Mr. Black took off his jacket, I scanned the room. It looked like any cheap hotel room, except there was no TV and the window was boarded up.

Mr. Black folded his jacket over the back of a chair and looked me up and down. He smiled. "Take off your clothes." The blood thundered in my ears. I stared at him. He stared back. The smile faded. I did what I was told.

Once I was naked, Mr. Black unzipped his fly, pushed me back on the bed and forced himself inside me. The pain seared up through my body and exploded inside my head. I tried to make my mind leave my body, but I couldn't concentrate. I couldn't find any patterns to lose myself in. Pressed against me, Mr. Black smelled of cheap cologne and stale sweat. He grunted with every thrust, an angry noise like that an animal possessed might make. He was hurting me, and when I began to cry . . . he began to smile.

"Tell me you love it," he said. "Tell me you love it!" When I didn't speak, he thrust harder and faster into my tense, unwilling flesh. *"Tell me you love it! Tell me you love it!"*

Tears rolled down my face and into the back of my throat. "Yes," I whimpered, "I love it." As he climaxed I felt thousands of insects crawling through my cadaver body, sucking the cold, blackened blood from my veins. Mr. Black grunted a few times, and then withdrew.

I lay there like a piece of garbage, waiting for his next move.

"Get dressed," he said, getting up and going to the dresser.

As I stood to pull up my underwear, he lunged at me, forced me against the wall and stuck the point of a knife against my

ribcage. "I've killed bitches that misbehave before," he said. "You fucking hearing me?"

I couldn't respond. All I could think was that I was only sixteen years old and I was about to die in this squalid building with this odious man. "Please," I whispered, tears pouring down my neck. "Please don't kill me. I'll do anything. Anything."

For a moment he stood there, eyes crazed, the point of the knife like fire on my skin—then he burst out laughing "You should see your face!" he cried, pointing the knife at my eye. "It's priceless!"

I stood there trembling, my heart bursting with fear, hatred, anger, relief, joy—and gratitude. He had not killed me. He put his lips close to my ear. "Now, you go back to your room and have a little think."

I picked up my clothes and crept to the door. Looked back at him. "Thank you," I said, and let myself out.

I was shaking so violently I could barely walk to the room he had pointed out to me before. Once inside, I sat on the edge of the bed and fell to pieces. This man had shredded my mind and body, but there would be more to come. I knew it. And there was no way out. The big old place with its boarded up windows was a prison. No one from home would come searching for me, not for ages, if ever. Even though I was only sixteen—a few months shy of seventeen, but still a minor—my family had gotten used to not hearing from me for months at a time. And even when I was still living among them they never raised an eyebrow when, at the age of thirteen, I would stay out at parties that ran for three consecutive days. Going off on my own was just the way I was.

And my boyfriend, Paul? He thought I was having a portfolio of glamorous modeling shots made, both in London and on

the Continent. He wouldn't even expect me to ring him up, as we had no telephone. He might wonder why I didn't write him a letter or send a postcard of St. Paul's or the Eiffel tower, but I was busy, wasn't I? That was what he would tell himself. After all, he knew his girlfriend was out doing something wonderful, making a ton of money, beginning her new career.

No help was coming.

I ran a shallow bath and lowered myself into the tub. My tears fell into the tepid water as I gently washed my torn vagina, knowing that it would eventually heal. I wasn't so certain about my mind. Finally, I crawled into the bed, adopted the fetal position and cried myself to sleep.

Later that night there was a soft knock at my door. I shuddered as a key turned in the lock and the door opened. Now what? Bright yellow light from the corridor outside blinded me, but when my eyes adjusted I recognized the tall form of Mr. Smith—Mr. Black's business partner.

I really didn't know what to expect as he sat down next to me on the bed. "I heard you crying. Is everything okay?"

I told him what had happened and sobbed, "I just want to go home . . ."

He put his arm around me and lifted my chin up, and gave me a kindly smile. "You know, you look just like my dead wife—and I'm going to fuck every orifice you have." And he did.

The next time I woke, Mr. Black was standing in my room, fully dressed. "Clean yourself up," he said. "Fix your hair and your makeup. I'll be back to get you soon."

I said nothing, but the moment he left, I crawled out of bed. I ached all over. Mr. Smith had been even worse than Mr. Black, forcing himself inside me again and again, tearing me to shreds,

then walking out of the room without a word and leaving me there bleeding.

While he was at it I hoped I would die. Just die of mental trauma so I would no longer have to be there. Or go into a coma from which I would one day awake in a safe place, surrounded by nice people who would take care of me. But of course that was just another version of my dream about a wonderful world. It wasn't going to happen. The dream wasn't real, and never would be. The pain I felt now; the terror, humiliation, degradation—those were real.

So I did what Mr. Black asked. I slipped into the lovely dress I had been so proud of; I fixed my hair and makeup. As I applied my red lipstick I paused and stared, horrified, at my reflection in the mirror. I did not recognize the person there. In a single night, the girl I had known had disappeared. The creature I saw before me was a flesh-covered robot, nothing more.

Mr. Black opened the door. "Get up and follow me."

A minute later we walked into a huge room that might have been the lounge of the former hotel. It had no visible windows, the walls covered in different-colored fabrics. In the middle stood two broken-down couches, a handful of chairs, and a coffee table overflowing with pizza boxes, Coke bottles, and ashtrays brimming with cigarette butts. Two men I had never seen before sat on one of the couches, laughing and rolling joints, oblivious of or indifferent to my presence. On the other couch lay two hungry-looking German shepherd dogs, their eyes alert to every movement.

Hard-core pornographic magazines, some featuring photos of children and animals on their covers, lay about like regular coffee table publications. Bondage gear hung menacingly on hooks, and dirty, used sexual toys were strewn around the

floor. Filming equipment—tripods and lights, cables and cameras—were everywhere. A man was trying to load film into a video camera while continually dropping things, muttering and swearing to himself.

In the far corner of the room, a wrought-iron bed covered in purple satin sheets squatted on a fake fur rug. In another corner, five half-naked girls were trying on garments from a huge clothes hamper. Some of the girls were younger than me, and each wore a numb, vacant, bewildered look on her heavily made-up face. No doubt all these girls had recently answered an ad seeking models for glamorous, well-paid work . . .

Mr. Black pointed at the hamper. "Find yourself something sexy to wear." As I dug into the hamper the other girls did not acknowledge my presence, nor I theirs. There was not even any eye contact.

After Mr. Black approved our outfits, he told us to sit down. "We're about to watch a picture show," one of the unfamiliar men said, and laughed. "I'll go and fetch the popcorn." They showed us some footage that included sadomasochism, gang-bang rape, and a woman performing fellatio on a German shepherd.

As I watched, I knew I would do whatever they asked me to do—or did to me. Or more accurately, I would go through the motions. Mr. Black and Mr. Smith had broken me in a way none of the previous abusers in my life had managed, because from this situation there was no escape. Here I was like a performing circus animal and, like a circus animal, I would do as directed—and I would do it in the same remote, impassive way.

The two men on the couch turned out to be photographers, and they ordered each of us girls in turn to perform sexually, in front of both a video camera and a still camera. When my moment came I tried to comply with their demands, like an

undead actress obeying an insane director's commands. Turn this way. Turn that way. Smile. Pout. But when the photographer told me he wanted "butcher's shots," I looked at him in confusion. He laughed. "Your meat; open your fucking legs wide, darlin'!"

I hesitated, and in that moment my detachment collapsed and the tears flowed. This was not the look the photographers wanted. Mr. Black whacked me around the head, then leaned down and whispered in my ear, "You know what will happen to you if you don't cooperate, don't you?"

That only made me cry harder. When no amount of shouting or threatening put a stop to the tears, Mr. Black threw his arms up like a demented diva and bellowed, *"Fuck off back to your room!"* Upstairs, I sat on my bed with an ashtray for company. Smoking, and rocking back and forth.

One day merged into the next, or so I assumed. In this building there was no separation of day and night. The windows were boarded up, the lights left permanently on. At any given moment I could hear both male and female voices screaming, laughing, swearing, shouting. Time had no meaning here.

I was put into rooms with prostitutes and their clients in order to "learn," as well as to participate and to be filmed. I was raped repeatedly; beaten; threatened. Wrapped once more in my impassive shell, I did as I was told, without question.

Here and there in the old hotel I saw patterns on wallpaper or pillowcases, but I could no longer turn them into beautiful images of an alternative and far better world. So instead I learned how to totally numb my mind; to become an automaton. In that condition I had no free will. *They* had ripped it out of me and consumed it entirely.

One morning after what might have been days or weeks of imprisonment, I was taken to a suite of rooms situated on the top floor of the hotel. When the door opened, there stood a grossly obese black woman in her forties, dressed in a black and red negligee. An astonishing sight, but nothing compared to what I saw behind her: a perfectly ordinary-looking apartment, complete with morning sunlight falling through an uncovered window.

The woman looked from me to the man who had brought me up and said, "Go away" in a strong Jamaican accent. To my amazement, the man did so. Who was this woman? Did she *live* here? By *choice?*

She gestured me in, then guided me to her bedroom and locked the door. I stood petrified as she slid off the negligee to reveal her massive bulk bulging out of every opening in the flimsy lingerie. She laughed at my facial expression, then proceeded to show me lesbian pornographic magazines featuring images of herself in hardcore action with other women.

As I realized what she wanted from me, my heart pumped faster and my breathing tightened. The woman opened her wardrobe to reveal a collection of horrific sexual toys: dildos of all shapes, sizes and colors; handcuffs; latex masks; whips; objects for which I had no frame of reference at all.

The woman tried to remove my clothes. In my horror and fear, I burst into tears. "No, I need to use the toilet!" I said.

She scowled. "No . . . you play wit' me now."

I edged away until I reached the small window next to her bed. Pushing the net curtains to one side, I stared out in desperation. Rows and rows of small gardens extended in all directions, yet there was not a person in sight. No one to hear me shout, *"Please help me!"*

The woman loomed behind me. "Get away from de window, you."

I turned and ran toward the bathroom door. "I've got to go. I'm going to wet myself."

With amazing speed for a woman her size, she stormed up and struck me across the face so hard I flew onto the bed. Being hit by a woman . . . well, this was something very familiar; something I knew how to handle. I composed myself and stood up.

She struck me again. "You stupid fucking white bitch!" I said nothing, did nothing. "*Okay, you go to de toilet!*" She threw open the bathroom door. "In dere . . . *stupid* white bitch!"

I hurried past her, closed the door. Locked it. Now what? What was I going to do? What *could* I do?

I flushed the toilet and turned on the tap while I frantically tried to think of something. The bathroom had its own tiny window, far too small to squeeze through. And we were about five stories up.

"Hurry it up in dere," the woman snarled from the other side of the door.

That was when I spotted the razor: the kind that gripped replaceable blades in a metal handle. I opened it and removed the blade. Held it to the light for a moment, then clutched it between my thumb and forefinger, turned toward the door and shouted in a shuddering voice, "I'm going to cut my wrists! I mean it! I mean it! Really deep!"

The woman started banging on the door and shouting words that I couldn't understand. I slid down the wall into a seated position, sobbing and clutching the blade against my wrist. This was it? This was my plan? What was I thinking? They didn't care if I died!

The screaming and pounding ceased. I crouched there like a cornered fox waiting for the hounds to come and tear me to pieces. After an eternity of silence I decided I couldn't take it anymore. Still holding the razor blade, I opened the door. The apartment appeared to be empty. Pressing the blade back against my wrist, I made my way to the outer door and peered over the banister and down the stairs. Nothing. Nobody. I didn't understand. Were they waiting to ambush me? I strained my ears but heard only the tension of fear within my own body.

Then I couldn't take it anymore. Fingers bleeding from squeezing the razor blade so tightly, I ran down the stairs. Found a fire door and pushed on it—and to my utter disbelief, it opened. Veins pumping inside my throat, razor blade slick with blood, I edged outside.

Sunshine. Clear air. I would run now. It didn't matter where I was, I would run and run until I came to a police station. I would tell them what was going on in this hellish place. They would give me coffee . . . and I would be safe . . . so safe.

Just then Mr. Black stepped in front of me, appearing as if from nowhere. He threw his cigarette to the ground, stamped on it and twisted it out with the toe of his scuffed leather shoe. Then he looked up at me and smiled. "And where the fuck do you think you're going?"

Out of Bondage,
Out of My Mind

Mr. Black took me back to my room and raped me. Afterward, as he pulled up his trousers, he told me that if I continued to not do as I was told, he would have no choice but to "offload" me. I knew what "offload" meant, and guessed that in the context of this evil enterprise it meant he would sell me to someone else. That terrified me all over again. Here, at least I was familiar with the devils.

An hour or so later, as I sat in the bath to relieve my pain, I made a decision. I thought about how the brain often shuts down during physical trauma, as when people sustain life-threatening injuries in accidents. That's what I would do. I would detach my mind from my body before what was left of the human part of me was damaged beyond repair. I would isolate it in order to protect it.

So that was what I focused on. That was what I conditioned myself to do every time I had to perform, every time I was threatened or raped. Not just accept, not just endure. Instead,

detach. Although I had been molested as a young child, this ordeal was on a whole different level. This gang of malevolent men were raping, beating and threatening to kill me at any moment. I never knew from one minute to the next what was going to happen to me. Completely shutting down all my senses was the only way I was going to make it through this emotionally—if they didn't kill me first. It was an extreme struggle of mind over matter, and resiliency, that sustained me and helped me to survive this total human degradation.

Late one night I was driven to an apartment about half an hour away. During the journey I sat staring at my feet with no thought of trying to attract attention, far less escape. I had become precisely the silent, obedient slave my captors wanted me to be. With my heart and soul sealed away, I was nothing but a piece of meat for consumption.

I found myself standing in the kitchen of a small, thin, expressionless man in his early forties. His eyes were as black as the long, greasy hair that stuck to his unshaved chin. He glanced at me while tucking his long-sleeved denim shirt into his jeans. Then he took the cigarette out of his mouth, pointed at some Chinese takeout on the counter, and asked me if I was hungry.

"No thank you."

"I insist."

Like the good little robot I was, I sat down at the round wooden table and aimlessly pushed the food around a white china plate. The man talked and talked, but I wasn't listening. I just answered, "Yes," "No," or "I don't know" to his banal questions.

After he threw away the empty cartons and bags, he washed his hands and told me to follow him to the bedroom. I did so,

moving with dull fatalism. He asked me to sit on the bed with him while he watched some TV and waited for his food to go down. I did that too. Although I heard muffled voices coming from the television, my mind was somewhere else while I waited for this complete stranger to execute his malice aforethought.

Without warning he jumped off the bed, turned off the TV and announced that he was going to show me "something special." I stared at his reflection in the blank television screen as he opened the door of a built-in wardrobe and extracted a drawstring bag of black velvet. I waited to see what new kind of degrading sex toy came out.

My eyes widened and my breath stopped as the man extracted an enormous handgun. "It's a .45," he said, stroking it. "Do you like it?"

"Is it l-l-loaded?"

He laughed. "Of course! Not much point of having an unloaded gun, is there?"

Caressing the gun constantly, he went on to talk about his many manly conquests. I barely heard him. Finally he looked at me, smiled, and ordered me to take off my clothes and lie down on the bed. He placed the gun on the bedside table with the barrel pointed at my face, then proceeded to rape me.

I closed my eyes and forced the imaginary steel shutters to envelop my brain. The man boasted about the circumference of his penis and how he had pleasured hundreds of women. Again, I barely heard him. He could ravage my body all he wanted, but I would not allow him to touch my mind.

No one could touch my mind . . . no one could touch my mind . . . no one could touch my mind . . .

Late one night, I was awakened by Mr. Smith. "Sit up."

I did as he asked, and waited for my next task.

To my surprise, he sat beside me and handed me a cigarette. He flicked his lighter and lit it for me.

"Do you want to go home?" he asked.

"Home?" I stared at him. Why was he asking this? What kind of cruel trick was he about to pull? But I couldn't help answering with the truth. "Yes . . . yes, I would like to go home."

He rose from the bed and locked my door. Coming back he whispered, "They've got plans for you. They're gonna sell you to an Arabian gentleman, so you'll leave the U.K. and never see your family again. So . . . do you want me to get you out of here?"

"Y-yes," I choked.

"If I do, can you get me money?"

"Yes. I can get it from my parents, they have money!"

I told this lie promptly and convincingly. I had no idea why this man was willing to go against his partner's desires, nor did I trust him—but he was presenting me with what might be my only opportunity to escape this place.

"Be packed and ready to go at five-thirty in the morning," he said. "I'll come and get you."

After he left, I paced the floor, chain smoking and trying to suppress my newfound hope in case it was all a trick or some kind of cruel torment. I did not go to sleep; with no clock or watch, I had no way of knowing when 5:30 might arrive. So I paced and smoked what seemed like hundreds of cigarettes . . . until I heard a key turn in the lock.

Mr. Smith opened the door quietly and beckoned. I darted out of the room and followed him along the corridor. I was afraid someone would hear my heart pounding like an over-

worked race horse. I thought my legs would collapse as we hurried down the stairs and out of the building.

I thought Mr. Black would be standing outside, waiting, smiling, knife in hand. But he wasn't, and we walked rapidly down empty streets for about ten minutes. Finally, at a taxi rank Mr. Smith flung open the door of a cab, and I dived through the opening before he could say "Get in."

We arrived at Euston Station just in time to catch the early morning train to Birmingham. As we sat in our seats waiting for other passengers to board, I thought I was going to have a heart attack for fear this would turn out to be a dream.

"Relax," Mr. Smith said. "I'm going to get some coffee. Don't move. Don't talk to anyone."

While he was gone I looked around at the other people getting into their seats. One man opened a newspaper, and I stared in shock at the date on the masthead. Was it possible I had been in that hellhole for only a few weeks' time instead of years, decades, an eternity? What would happen if I told one of these commuters what had happened to me? What was happening to me *now?* I thought about it, but didn't try to find out. I knew better, now, than to trust anyone in the world, however normal-looking, however well dressed. Everyone was out to take a bite. And anyway, if I blurted out my story to anyone, they would undoubtedly dismiss me as a nut case.

Mr. Smith returned just before the train pulled out of the station. Blinking back tears of loathing, I watched the city of London disappear into a smoky blue horizon.

I'm not sure how long I slept, but I awoke with my head rapping against the window to the rhythm of the train. Outside, fields and trees whooshed by and for a moment I forgot where I was and who I was with.

"Hello, Sleeping Beauty," Mr. Smith said as he extinguished his cigarette. I looked at him, hating him and wondering how he planned to proceed once we got off this train at Birmingham. On the other hand, he did get me out of that hell house; I had to be so thankful for that, didn't I?

Mr. Smith surveyed the other passengers for a few moments, and then lit another cigarette, stood and gestured for me to follow him. I knew something horrible was about to happen, and when he gave me "that" smile I knew what the "something" was. So I pulled down my inner steel shutters and prepared for the worst.

After a last check of the passengers, Mr. Smith ushered me into the train's toilet and locked the door. He threw his cigarette into the toilet bowl, pulled up my dress, and turned me around to face the wall. As he undid his trousers and forced himself inside me, I yelped. He clamped his hand over my mouth. "This is part of the deal," he whispered, "so shut up and take it."

He raped me again and again, all the way to New Street station.

I was in terrible pain as we walked the short distance to the taxi rank. "Remember," Mr. Smith said as he stamped out his latest cigarette and opened the cab door, "don't tell anyone anything." During the ride to my flat he murmured, "I'll be watching you go inside to make certain you actually live there. And then I'll know your address as well." The undercurrent was clear: there would be no getting away from him. He questioned me about my boyfriend's work hours so he would know what times he could come and visit me and find out about the money.

Then I ran up the stairs and let myself into the flat with the key that had been stashed in my suitcase. The faded paint, worn walls, tatty furniture: it looked like heaven to me. I stripped

off my noxious underwear and sat myself inside a bowl of warm, soapy water to try and cleanse, heal and purify myself. I remained there until darkness fell, staring into space and chain smoking.

Then my body began shaking. Although I was safe inside my own flat, I wanted to scream and sob. But nothing would come; not a single tear. I was in psychological limbo, dangling motionless over no man's land, too scared to face my own emotions. The only feelings that touched me were those right on the surface: shame, guilt, humiliation.

It's your own fault; that's what Mother would say . . . and she would be right. What had ever made me think I could leave the life into which I had been born? What had made me think I was so high and mighty that I deserved freedom and money and travel and joy? I had gotten exactly what I deserved. So I would tell no one about it. I would deal with the consequences the way I always had: by myself. I would tell everyone what a grand time I had had. I would describe photo shoots in studios and on location. I would say I was waiting to hear about the modeling work that would surely soon come my way.

Paul had been staying with a friend of his while I was gone, and the two of them walked in the door not long after I had come home. I suppose he was happy to see me, though he certainly didn't seem enthusiastic about my return. "Oh, you're back!" he said, surprised. "How are you? Did you enjoy yourself?"

I feigned a smile and lied, "Yeah, it was great. I made some good contacts, so I'm just waiting for them to get in touch."

"Good," he said half-heartedly. He puttered around for a while then said "Well, we're just off to the pub, do you want me to bring back anything for you?"

Hardly the welcome I expected, I forced another smile and said, "Could you get me some tobacco please?" and that was about it. He almost immediately fell back into his schedule of working six days a week and leaving most nights to visit friends and family.

Mother asked a few questions about my "modeling career in London," but expressed no particular joy at my return.

Strangely, it was Mark—now my stepfather—who realized something was not right with me. "What happened in London?" he asked a few days after my return. "And don't say 'nothing.'"

"Nothing."

He pressed me, but I wouldn't tell him anything. My problems were my own responsibility. Plus there were the consequences Mr. Smith had threatened me with if I spoke to anyone about his operation. For all I knew, he was waiting outside at that very moment, wanting the money I had promised him.

But Mark was as stubborn as I. He drove me to the nearest police station, where we stood in line for the opportunity to approach the desk sergeant. When we finally reached him Mark explained that I had gone to London with a man claiming to be the manager of a modeling agency—but that since my return I had been acting "really strange."

The sergeant looked at me through his spectacles. "Is this true?"

I hung my head.

The sergeant raised his voice. "What exactly took place? Did the man hurt you in any way?"

I was surrounded by dozens of waiting people, Mark, the desk sergeant. They were all staring at me, straining to hear my answer. They were all waiting to judge me. If I answered "yes,"

they would condemn me as a fool, a gullible little girl. I would have to deal with the humiliation and shame coming at me from both them *and* myself. I was scared, and somehow I believed that this was all my own fault and that I, alone would have to suffer the consequences.

"No," I murmured. "Nothing happened."

The sergeant scowled. "Well, you're a silly little girl for going to London with a strange man." He looked at Mark. "If she's not going to make any statements or press charges, then there's nothing I can do."

Mark turned back to me. "Please. I know something happened; tell him."

"Nothing. Nothing."

"Please."

I shook my head. I would never tell anyone what had happened to me. I would bury the memory so deep inside me that it could never harm me or anyone else.

During the following months I lived in constant fear. Every few days, Mr. Smith would come to the flat during the daytime when Paul was gone and bang on the glass panel in the front door. I hung a curtain over the panel so he couldn't see in, and stopped playing music or watching TV during the day so nobody could hear anything from within the flat. Even so, when Mr. Smith came knocking I hid behind a chair in the lounge, or in the shower, or curled up on my bed, and I did not move until I was absolutely sure he had gone. Sometimes he shoved notes through the letterbox: "I need to see you. I'm not going to hurt you."

Did he really think I would believe that?

When I had to go out, or when being a prisoner in my own flat became too much to endure, I would check carefully for Mr.

Smith before sneaking out. Still, he made his presence known. Early one evening when I went into the shop to pay the week's rent, the landlord handed me a note. "There was a blond man in here earlier looking for you; he left this."

I walked outside, and with trembling hands tore the note open. It read, "You have to meet me, if you don't, you know what could happen to you."

After that my fear became terror. I jumped at any little sound. Even sleep offered little respite: I woke from dreadful nightmares about Mr. Smith breaking down the door and killing both me and Paul. I'd also have horrific flashbacks about my captivity.

So I decided to do something. I cut my long auburn hair to a half-inch stubble and died it platinum. I put on punk make-up and clothes, and once again started to frequent pubs, clubs and parties. I consumed all the alcohol and drugs I could get my hands on. My weight plummeted to six stone—about eighty-five pounds. When some of my friends voiced their concerns, I said I was okay.

But I wasn't okay. I had begun the decent into the nadir of depression.

Descent into Madness

The descent really began when I stopped going out.

By "going out" I don't mean just to clubs and parties; I stopped visiting friends and family, spending time in the city center or going into local shops more than absolutely necessary.

My fear of Mr. Smith was a big part of it, but there was another reason I began to sequester myself: eczema. I had always suffered from this skin disorder, but only occasionally and in small patches. Now it ran rampant. Sores broke out on my arms and legs, then my torso, scalp, even my nipples. No medications seemed to work, and without a bathtub or a shower that worked, I couldn't wash myself properly. I felt like a walking contamination, and became a reclusive leper hiding from the outside world.

The itching grew most intense at night. I would stay awake for hours, rocking myself and trying desperately not to scratch. But inevitably I would surrender and claw at myself until my skin opened and my nipples bled.

One day, unable to stand it any longer, I asked a friend if I could use her bath. As I began to undress I discovered that I couldn't actually take my clothes off—they were stuck to the drying, weeping wounds all over my body. I had to climb into the tub fully dressed and soak myself until I could safely remove the garments.

Most of my days were spent sitting in a chair staring at the television screen, even though I could not focus or concentrate on it. I had no appetite. Eating required more effort than it was worth, especially since the chronic tightness in my throat made swallowing difficult. Sometimes I sat at my bedroom window for hours, watching people outside going about their business. My fear of Mr. Smith did not stop me from going out; I simply felt no desire to interact with anyone.

Late one night I felt a squirming sensation inside my back passage. I thought for a moment that I had imagined it, so I dismissed it—but an hour later it happened again. Troubled, I decided to check it out. To my horror, I discovered thin white worms coming out of my anus. I paced the floor and chanted "Oh my God . . . oh my God . . . oh my God." What could I do? What was happening to me? Perhaps I was hallucinating, having a flashback. Or maybe . . . maybe I had actually gone mental.

I panicked. What if there were *hundreds* of the white worms wriggling around inside of me, swimming inside my veins, laying their eggs in my organs? What if they were inside my brain, and that was why I had gone mad?

Just then I heard my boyfriend's motorbike pull up outside. By the time he stepped into the flat I was so hysterical he could not understand a word I was saying, and had to calm me down. Finally I told him I had hundreds of white worms inside of me,

and he had to go to the hospital and tell them. He leaped back on his bike and sped off.

While he was gone I felt as if my mind was going to explode. I paced, I smoked, I sobbed, I looked out of the window every few seconds. When Paul finally opened the door I felt my eyes and mouth stretch wide open, as if on the verge of a scream. "It's all right," he said. "The doctor says it's nothing to worry about; it's a common ailment. You can buy a preparation at any pharmacy to expel the worms."

I did not go to bed that night. I did not sleep again until I had purchased and swallowed the drug that would kill the parasites inside me.

Eventually Mr. Smith stopped appearing at the door. Even so, I stayed in the flat, usually alone. Every sound grated on my nerves: the ticking of the clock, the dripping of the broken shower head, even the sound of my own breathing. It was so quiet in the flat occasionally a rat would wander in looking for food, unaware that I sat a few feet away watching it. I would bang my foot on the floor to see if the rat reacted, to confirm that the animal was real and not something I was imagining. I had buried my trauma into a very deep place. I'd had flashbacks about my captivity, but usually only after I had seen Mr. Smith. When he stopped coming they stopped. But now I was left with this mess of a body and mind. Maybe it was the trauma and the stress coming out, since I would not allow myself to think about nor talk about what had happened to me.

I viewed myself with disgust: I had protruding bones, weeping sores and scabs. The breaking apart of my skin seemed to parallel the breakdown of my mind. Sometimes I peeled the scabs off and ate them, or banged the back of a heavy metal spoon onto

them. I needed to feel the pain—to feel *something* to assure me that I was alive. But one Sunday evening the anguish grew so tortuous I sat rocking myself and whispering, "I'm going mad. I'm going mad. I'm going mad."

Finally I took all of my clothes off, sat in the shower tray, and poured a whole bottle of cochineal over my own head. Cochineal is not a medicine; it did nothing to ease my itching. I dumped it over me because it was the same vivid red color as blood. This was how things would look if I were to take a razor blade to my wrists. If I were sitting there bleeding to death. It wasn't so bad. Dying would end my distress.

I sat there in the pretend blood, hugging myself and crying. But it was not a woman's cry. It was the strangled whimper of a child with no mouth.

By the time the sun rose I knew I had reached my breaking point. At 9 A.M. I strode out of the flat and walked to the local medical center. I asked the receptionist for an appointment. She flicked through the heavy appointments book. "I can do you one for next Tuesday," she said.

"I'm sorry," I said, "but I really need to see a doctor right now."

She raised her eyebrows and looked around the crowded surgery. "As you can see, we are full to capacity. I can't possibly offer you an earlier appointment."

"I'm really sorry, but I need to see a doctor *right now*." Tears welled up in my eyes.

The nurse looked at me for a moment, then said, "Wait a moment while I have a word with one of the doctors."

Behind me, the room fell silent. I could feel eyes boring into the back of my head, but I didn't care. I was determined to see

this through: not next week, not tomorrow, but now. My life depended upon it.

The nurse returned and asked me to follow her to a recreational lounge, where she presented me to a doctor. He took a slurp of tea. "What's wrong with you then?"

Again the tears welled up, and I removed my jacket and top. "What's wrong with me? *This* is what's wrong with me . . . and if you don't help me I'm going to die."

He scanned my upper body and said, "Yes, I can see this would be a problem for you. What medication are you on at the moment?"

"I'm on every kind!" I thrust out my arms. "Look at me! *I'm going to kill myself!*"

"Okay, okay," he said, holding up his hands. "I'll make an appointment for you to see a dermatologist at the skin hospital."

Unless you pay privately, which of course I could not, the National Health Service procedure for medical care is long and arduous. First, you go to a general practitioner. If she or he deems your condition serious enough, they will refer you to a specialist, who is generally based in the department of a hospital. If you live in a large city, as did I, the wait to be seen can be extremely long because of the large population. For something not life-threatening, it is not inconceivable to have a wait time that is *years* long.

For the next week I watched for the postman every morning, like a hawk for its prey, waiting for my appointment to come through. But as the days passed, I noticed that something was wrong with my left thumb. It became very painful and nearly doubled its size. Perhaps the dermatologist could look at this, too.

At last the letter from the hospital came. I opened it frantically and scanned the words until I came to the date of my appointment: four months in the future.

After my sobbing subsided I went into my bedroom, got dressed and applied some makeup. I gathered a few things and caught a bus to the city center. During the ride I gently stroked my left arm, which had now also swollen to almost twice its normal size and was excruciatingly painful.

When I reached the skin hospital I marched past crowds of waiting people directly to the receptionist, who asked if I had made an appointment. "I'm sorry," I said, just as I had at the first clinic, "but I need to see a doctor *right now!*"

Realizing I was in great distress, she told me to wait a moment and vanished through a door. A few minutes later she returned and asked me to take a seat. She said, "Someone will see you at some point today." That was better than in four months. I sat down.

Eventually I was called into one of the dermatologist's offices. "Right then," he said. "What can we do for you?"

I explained everything and emptied my medications onto his huge oak desk. He went through the bottles one by one and threw most of them into the bin. "And what is this for?" he asked, holding up one of the tubes of ointment.

"I was given that for my nipples," I answered.

"*Nipples?*" He looked horrified "This is a preparation for athlete's foot, this is a fungicidal treatment!" He threw the tube into the bin. "Okay. Let's take a look at you."

He opened the door to the examination room, and requested that I strip to my underwear. I did so while he adjusted a huge magnifying glass and flicked on some powerful lights. Then he turned toward me, peering over the tops of his spectacles. His

eyes widened. "Good God! What on earth have you been doing to yourself, you silly little girl?"

I said nothing. He swung the huge lens over and started scrutinizing every inch of my skin. When he raised my left arm I winced with pain. *Tut-tutting*, he told me to get dressed and come back into his office.

He was writing something in a file when I re-entered the room and sat down. "Right!" he said. "First of all, I want you to take this letter to the hospital's registrar and admit yourself as an inpatient."

"B-but I didn't expect . . . you mean now? Right now?"

"Yes, right now, my dear. You have septicemia, blood poisoning. You have infected your blood, do you understand? This is serious!"

"But I don't have anything with me, and nobody will know where . . . "

He raised his voice. "Do you want to die?"

I thought it best not to answer.

I managed to call Paul's mother from a call box within the hospital and asked her to get word to him about what had happened to me. I got hold of my family, too.

I was admitted and given huge doses of penicillin and other drugs. My condition was so bad a photographer documented it for posterity. Back on the ward, they ran me a bath of coal tar and other emollients, coated me in ointments, cut off my nails and bandaged my whole body in crepe tubing. They double-backed the tubing over my hands to stop me from so much as touching my skin. I looked like a skeletal mummy.

I spent almost a month in that hospital, receiving daily treatments and clean dressings until my skin cleared up. During that

time no one in my family visited, and Paul only once or twice. That was fine with me. Being so long in hospital was unpleasant, but at least the place was a safe haven. There, I didn't have to be scared. I had forgotten what it was like to *not* be scared.

I wanted desperately to experience that feeling again after I was released. I decided to take steps to change my life, starting with getting out of my miserable flat once and for all. One day, while Paul was visiting me in the hospital, I said, "I can't bear to live in that horrible, depressing, damp, pokey little flat anymore; it's ruining my health!" I cried, and listed all the ways that I hated it, and added that I wanted to live near my family and friends. Paul agreed and we decided to look into getting a council flat.

Perhaps if I gave my tormented mind some respite, I could start to actually feel . . . happy.

The Princess
in the Tower

Unfortunately, we found out there was only one way we could qualify for a council flat: to be married. In the 1970s, the city council would not allow unmarried couples to rent council property. It was becoming apparent that our relationship was no great love match but we decided to go ahead with the marriage anyway. Unceremoniously, Paul said, "Okay, let's do it." Because I was still not a legal adult at seventeen, I needed my mother's permission but that would not be an issue; she really didn't care.

Marriage was pretty meaningless to me at that time anyway, as to many people. The common attitude was that it was "just a piece of paper." Paul and I wed at Birmingham's main registry office without a lot of fanfare.

A few months later we were offered a ninth-story flat in a high-rise tower on the edge of the estate where I had grown up. At first I felt relieved and happy.

Unfortunately, as the months went by both my eczema and

cystitis returned, so I had to get medications again. During one visit to my doctor I mentioned the fact that I felt sad most of the time and had trouble sleeping. He didn't ask me why I felt so blue, he just took out his pen and added "Valium" to my prescription.

But the Valium just seemed to make things worse. Instead of having trouble sleeping, I had trouble waking up. And when I *was* awake I felt inert, lethargic, vegetative. I lacked the energy to get off the couch, and lost all interest in life.

So again I hid myself in my flat. Its anaglypta-covered walls became a prison in which I was the custodian of my own incarcerated mind. Even when the sun shone into the room, my world was a funereal black.

One afternoon I attempted to cook a meal, and as I was slicing an onion, the knife slipped off the shiny skin and cut deeply into the tip of my thumb. Blood poured down my hand and dripped onto the floor. I sat on the tiled floor with my back against the cupboard and stared at the blood. So bright, like the cochineal I had poured over myself in the shower back in my old flat.

It didn't hurt at all. I moved the knife to my forearm and made a series of small cuts. They didn't hurt, either. I wondered if I would notice if someone hacked off one of my limbs. Next I made a few shallow cuts on my wrist. It would be so easy to push the blade in a bit deeper. . . .The only thing that stopped me was the fact that I was by myself. Dying alone was too dreadful to contemplate.

No one else knew about my inner torment. When family or friends visited, I play-acted that all was well. I said I was fine, everything was fine. I listened to people talking about themselves

and their problems, and I frowned or smiled at the appropriate moments, but in truth I didn't want anyone to be there at all. It was exhausting to keep up the façade. After guests left, I usually went straight to sleep, as if keeping up the pretence of interest exhausted me. In fact, everything seemed to exhaust me. Even breathing was a chore. Why couldn't I just stop breathing?

The television was my only real friend, a companion that distracted me from the deafening silence and the motionless clock.

Early one evening, Paul and I had a terrible argument about him always going out and leaving me alone. He said I had changed. *I* was the one who didn't want to go out anymore, so why should he stay in? Gathering his wallet and keys, he slammed the front door on his way out.

When he had not returned two nights later, I opened the door to the balcony and stepped into the bitter winter air. I looked over the wall at the sparkling concrete nine floors below. I dragged a small table to the front of the balcony and climbed upon it, shivering with cold and fear. Crouching there, I waited for the area below to clear of people.

My tears felt oddly hot as they ran into my mouth. I imagined my twisted, broken limbs and cold white face in a pool of frozen blood. Voices inside my head goaded me: *Just do it! Go on, end your shitty life! Just do it! Just do it!*

And I wanted to do it . . . I looked up at the clear, black-velvet sky, my tears freezing on my cheeks. The crescent moon and twinkling stars were so beautiful, so astoundingly beautiful. The table wobbled so violently from my shivering that I got scared and climbed down. I couldn't do it. I couldn't jump. I was too pathetic and weak even to throw myself off a balcony.

So I decided to do something else instead. I removed all my clothes. I would die as I had been born: naked, and in the fetal

position. I would fall asleep up here and freeze to death. Lying down on the rough, icy floor of the balcony, I curled myself up and waited for eternal sleep.

When I opened my eyes again, the moon had set. I was not dead. I had failed again. I tried to get up, but could not seem to move my body. Finally I managed to pull one of my hands out from beneath my face, pushed myself up and slowly rose to my feet. As I opened the balcony door and walked stiffly inside, I felt like I was entering a furnace. Although the heat was off, scalding air engulfed me. I stared into a mirror in fascination. My skin was blue-white, mottled with orange and purple, like a Victorian waxwork mannequin.

And yet I still lived. Staring at my reflection, I asked, "Who are you, and what have you become?" I did not answer. I prayed to God but he didn't answer, either.

A few months later, Paul came home very excited, and sat me down on the settee to tell me that he had been offered a great job as a paint sprayer of commercial storage shelving and the like—in Berlin, Germany. We agreed that despite the location it was an opportunity not to be missed. Living in Berlin we could save a lot of money, and then after a few years come back to Britain.

We decided that Paul would go first, settle into the job and find a house to rent while he continued to support me in our flat. I would join him at a later date.

There was only one problem with the plan: the moment I waved goodbye to Paul at the airport, a huge sense of freedom filled me. Although I was now truly alone, I felt less lonely than I had when Paul and I lived together.

Shortly after my suicide attempt I had gotten a job as a brass-rubber in a cathedral gift shop. The pay wasn't much, but I knew that I needed to be more positive and active in my own life. I didn't discuss my decision with anyone, or solicit any advice on how best to reach my goal. The idea never even occurred to me. I would go it alone, as I had always done.

I stopped taking Valium. Not gradually, as one is supposed to do; I just threw the tablets into the bin. For weeks thereafter I suffered a panoply of side effects, including panic attacks and uncontrollable shaking. At one point I could not even hold a cup of tea without spilling it.

As my ordinary feelings returned there were moments when I desperately wanted the drug to quell the emotional surges rampaging through me. On those occasions my brain felt as if it were splitting and dividing—lots of voices inside my head clamoring for attention.

I found myself feeling increasingly paranoid. Even though Mr. Smith had stopped tormenting me, I jumped half out of my skin every time I heard a knock at the door or the ringing of the telephone. If I went to a shop I would say as little as possible and avoid making eye contact for fear someone would notice my craziness and call the authorities.

Doing this day by day was incredibly difficult, but I refused to quit trying. I gave myself pep talks: *You can do this . . . you can beat this . . . you can be in charge of your own mind . . . you can win.* Then would come variations of *You can't do this anymore . . . it's too hard . . . just curl up in your bed and die.*

But gradually the good days began to override the bad days. The stronger I became, the stronger I got.

The job at the gift shop had been offered to me through a government-funded scheme to get people recovering from physical

or mental illness back into the workplace. It provided me with pocket money while getting me out of the flat for a few hours each day—but unfortunately was only seasonal. When winter arrived I found myself out of work again.

Browsing through the job ads in my local newspaper, I saw an advertisement seeking models for promotional work. I started to turn the page but then looked again. In my mind, the people who had held me captive before had nothing to do with real modeling agencies—that was just a ploy. This seemed genuine. I wanted to change my life, not act like a victim anymore. I had to live my life the way I wanted. After a moment's thought, I checked with the relevant government agency to make sure the modeling agency was a registered company. It was.

The agency was situated in the city center and was owned by a really nice woman. After my interview, she told me that although I was pretty and had a good figure, I was not tall enough to be a regular fashion model. Instead, she could offer me work promoting products at conventions and trade shows. I agreed, and for the next year went off to help sell merchandise all around the U.K. Paul called me about once a week but we still had not made plans for me to move—and I was fine with that, especially since I was working regularly.

On one job, I spent three days at a show at the Barbican Center promoting fiber optics. A young man running one of the booths taught me enough about the products to do a decent job. On the first night of the show, after we had had some dinner and a chat in our hotel, we walked upstairs together to our rooms. With each step my apprehension grew. I knew what would happen next: he would suggest that we have a drink in my room . . . as a prelude to sex.

At the first door he stopped, turned to me and said, "This is

your room, so goodnight and I'll see you in the morning."

As he walked away I stood there, stumped. "Okay, um, see you then," I stammered.

Lying on the bed in my room, I thought, *Does this mean he respects me, or that he was just not attracted to me?* And I realized I didn't care. It was nice to not have to fight a man off for once, whatever the reason.

At the age of twenty I eased myself back into society, first visiting friends, then going for walks and chatting to people in pubs, and finally getting more extreme: traveling, partying. Before long I was going out almost every night, even if alone to a cinema or a restaurant. I also started going to clubs again, usually along with Paul's younger sister, Dianne.

At one of these clubs she and I met some guys who were about to become one of the world's major bands, Duran Duran. Many nights we hung out together, partying, and then went back to my flat. Dianne began dating the bass player. It was a time of excitement, hope and renewal for me.

Meanwhile my husband Paul telephoned regularly from Germany, where he had settled into a nice apartment. He told me the work was good but he was lonely. I felt bad about that, yet could not conjure up any interest in joining him there. Although he was a nice man and had never abused me in any way, he also rarely showed me love or affection. We were more like friends than husband and wife—and I didn't want a friend. I wanted to be loved.

Much later I learned Paul was gay, and had married me mostly to appease his parents and grandparents. But at the time, all I knew was that I did not want to go to Germany; in

fact, I no longer wanted to be with Paul. I decided to arrange a visit to Germany so I could tell my husband face to face that I wanted a divorce.

Not long after that, I was awakened late one night by the violent jolting of my bed. It was pitch dark in the room, but I smelled the stench of alcohol. Once I realized it wasn't a dream and someone was kicking the bed, I reached for the light and sat bolt upright. A tall figure in a black trench coat stood at the foot of the bed glaring at me. It took me a moment to recognize Paul. "What the hell are you doing here?" I cried. "And why are you doing that? You scared the shit out of me!"

"Who's been in this fucking bed with you?" he slurred.

I had never seen him like this before: agitated and extremely drunk. I got out of the bed and put on my dressing gown. "What are you talking about and why are you here?"

He pulled a large, half-empty bottle of gin out of his pocket and gulped at it. "You're a fucking liar! I've been to the club and seen Dianne; she told me what you've been up to!"

"I haven't done anything," I protested.

He looked around the bedroom and saw some portfolio shots of me stacked on my dressing table. "Oh, so this is what you've been up to, you fucking whore." He started to rip the photographs to shreds.

"What are you doing?" I cried. "Don't do that!" As I ran over to stop him, he glared at me with such hatred that I backed off and watched silently while he continued to tear the photos into ever-smaller pieces.

"I hear you want a fucking divorce," he said. Before I could answer, he pulled open my drawers and began to tear, smash and break everything he touched. I fled into the lounge, lit a

cigarette and sat there smoking, trying desperately to think of what to do—while listening to his raging destruction.

Suddenly he banged open the lounge door and made his way into the kitchen where he continued to rant while smashing glasses and crockery and throwing utensils at the walls. I tried talking to him to calm him down, but his anger only escalated. My heart almost stopped as he staggered out of the kitchen wielding a huge carving knife. He lunged towards me, and in his drunken stupor tripped and fell over a chair.

I didn't wait. I bolted out the doorway into the communal hall, where I hammered on my neighbor's front door. When she opened it I shot past her and slammed it shut behind me.

"What the hell's going on?" she demanded. "All that noise woke me up; I was just going to call the police!"

"Please do," I said. We sat in her smoking lounge, listening to the dreadful noises coming from my flat: crashes and thuds mixed with the terrible, almost primeval sounds coming from Paul himself. I still couldn't believe it. This was a man whom everyone loved; a man who had always been the comedian, who made people laugh until they cried.

In the end three police officers were needed to restrain him. My neighbor and I listened as they dragged Paul out of the flat and tried to get him into the lift. He swore and kicked at them, but eventually one of the policemen knocked on the door and informed me that Paul had been subdued and would be taken to the police station where he would be locked in a cell for his own safety. The authorities would call his parents in the morning.

Filled with apprehension, I walked into my flat. The mess was indescribable. The place looked as though a bomb had exploded in it. My neighbor followed me through the debris. The destruction was complete. Paul had even slashed apart the

furniture, the carpets, the wallpaper. He'd cut my passport to shreds, as well as all my clothes, shoes and underwear. He'd even smashed all my little jars and bottles of make-up.

"What are you going to do now?" my neighbor asked me.

I shook my head. "I don't know. For the life of me, I don't know."

12

No One Asked
Me "Why?"

I could no longer stay in that flat. Not just because of the devastation, but because Paul made it clear he would no longer support me. Even with my job I still needed his income. He returned to Germany, leaving me with no choice but to go and stay once again at Mother's house.

She was now living with my younger brother Nicholas and her third husband—a scrawny, long-haired, bearded alcoholic named Andrew who Mother thought resembled Jesus.

There were only two bedrooms in their flat, so I had to share with Nicholas, who begrudgingly hung a sheet from the ceiling to partition the room and moved his stuff over to accommodate my bed and chest of drawers. I assured him that I was already searching for a place of my own and would not be there for long. The situation was strained and uncomfortable, but at least I had a roof over my head.

As soon as I settled in, I applied for a flat of my own and also petitioned for a divorce from Paul. The paperwork for the latter

required Paul's signature. He suggested that instead of my sending the documents to Germany, he would come back to Britain and visit for a week, or I could bring the documents to him for his signature.

I thought it over. Since destroying the flat Paul seemed to have reverted back to his old benign self. I had no fear of him, and wanted to sort everything out face to face if I could. So, in the autumn of 1981, I flew to Germany. I had never flown before, so I was very excited as the plane took off from Heathrow Airport. The only thing that niggled at me was an occasional uncomfortable twinge in my bladder.

It was good to see Paul—the Paul I had always known—again. We talked for hours, and concluded that ours was to be an amicable divorce; we would put our differences aside and remain on friendly terms. On the other hand, during the night and early hours of the morning I found myself peeing an awful lot.

As soon as the local pharmacy opened, Paul and I tried to relay my symptoms to the pharmacist in a kind of pidgin English/German/gesture language. I don't know what the hell she ended up giving me, but after I took two tablets my urine turned bright cadmium red. I threw the rest of the drugs into the bin and swallowed painkillers instead.

After a few days I was feeling well enough that when Paul suggested we go to East Berlin with a couple of his friends, I agreed. Visitors from the West were allowed in, though you had to go through several checkpoints and show that you had the proper documentation. I looked forward to the trip and hoped it might take my mind off my remaining discomfort.

After passing through the checkpoint in the forbidding Berlin Wall, we drove to the city center. It looked to me like a

movie set. Many of the building were still derelict from being bombed during World War II, and the rest, even absent rubble and debris, looked as if they were frozen in time circa 1945. It was a far cry for the Western world, or even West Berlin—it was like a living history lesson.

The next thing that struck me was the absence of color. Everything was different shades of grey, black and white: the buildings, the vehicles, the people's clothes. Hundreds of wild grey rabbits hopped around, eating grass, mating, fighting. Wooden sentry posts stood about in many locations, each containing guards balancing the butts of their rifles on the palms of their hands, standing as rigid as statues. It was surreal.

Inside the Berlin Museum I excused myself, as I needed the toilet desperately. I had drunk so much water over the past few days that my abdomen was as swollen as that of a pregnant woman. I was bursting to urinate, but when I sat on the loo nothing happened. I couldn't pee at all. After about half an hour of trying, I burst into tears.

And as I came out of the toilet, a cleaning woman stopped mopping the floor and spoke to me in German. I tried to express my symptoms by using my hands. She probably thought that I was expecting and having complications, for she sat me down and made the hand signal for telephoning help.

She ran off and returned shortly with another woman. Paul came in to see why I had been gone such a long time. Then two fully uniformed firemen came into the toilet. After speaking with the women, one of the firemen picked me up and carried me out through the museum and down the concrete steps. He placed me into the back of a fire engine and covered me with his coat. Paul was given a lift by his friends, who followed the fire engine to the hospital.

At the East Berlin hospital the fireman carried me inside, put me in a wheelchair, spoke to a nurse and left. Paul arrived, having followed the fire engine. I sat there next to him wondering what the hell they were going to do to me in this place. The corridors and the examination room reminded me of old black-and-white photographs showing the interiors of mental institutions.

I was staring up at a flickering fluorescent ceiling light full of fly carcasses when a round-spectacled, scar-faced doctor came into the room, accompanied by a stern, athletically built nurse. As they hoisted my legs up into stirrups, panic gripped me. *This is insane!* I thought. *This is like being in a horror movie!*

No sooner had the doctor put on some rubber examination gloves than he thrust two of his fingers inside my vagina. The pain surged through me and I screamed, clamping my hands onto his wrists. The nurse immediately restrained me, shouting words I couldn't understand. I started to cry, and then whimpered in relief as the doctor inserted a catheter.

I was taken to a room containing two other female patients, given medication and put to bed. I lay awake most of the night, listening to my roommates chatting in German. Still, I felt calm and relieved to be free of the pain.

I was there for two days before being transferred to the West Berlin hospital, where the doctors carried out a series of tests without being able to determine what was wrong with me. They were all perplexed and didn't even offer up an opinion of what might be the problem. After a few days hospital personnel arranged for me to fly back to the U.K. I was pleased. I was thankful to the hospital staff, but I just wanted to go home.

At Heathrow Airport a hospital porter collected me in a wheelchair and took me directly to Heathrow Airport Hospi-

tal, where I stayed for two long weeks. The first week consisted mostly of my undergoing endless tests and examinations. At one point I felt so down that I telephoned Mother and asked if I could come home.

"I'm having enough problems in my own life without having to look after you," she said. "You should stay there until you're better."

I felt the lead jacket of depression folding around me, and struggled to shrug it off. I had promised myself: never again.

The second week, the doctors removed the catheter but told me I wouldn't be released until I could "pee normally." That was much harder to manage than I had anticipated. To keep the flow going I had to literally retrain my brain by drinking lots of fluids, running the tap, tickling the base of my spine, and even singing. Then all of the tests came back: "inconclusive." They had no idea what had happened to me, but because I could now urinate naturally, I was released.

When I arrived home I found waiting for me an invoice from the Berlin Fire Department for seventy-eight Deutschmarks to cover the expense of my transfer from the museum to the hospital. Although the trip had been "quite a ride," I did not pay the bill.

Soon my divorce came through, and not long after that I was offered a ground floor flat: one room, damp and cramped, in a block of six situated in a cul de sac not far from Mother's place. I moved in immediately, not a difficult task given that all I possessed was a single bed and a large cardboard box and tomato crate that I used as table and chair. But I felt happy. I was free and independent.

On the other hand I soon discovered that my neighbors

were mostly social outcasts—drug dealers, users, alcoholics, prostitutes and ex-cons. It was an antisocial, inconsiderate and aggressive crew.

My saving grace was Carol, who lived in the flat above me. A vivacious cockney girl who stood four feet nothing, she could not place the soles of her feet on the floor because of years of constantly wearing high-heeled shoes. I could hear her clomping about in them even while she vacuumed her carpets. We became firm friends, going out together to pubs and clubs, or staying in with a bottle of wine to have a good old chat. We devised a system where if either of us became scared or worried about anything we would telephone one another and either get together or call the police. It was a most reassuring plan to have in place in that area.

Unfortunately, one evening while Carol worked her usual late night shift at a garage, two men robbed the place. One of them pointed a sawed-off shotgun in her face. The shock affected her so badly she decided to go back to her mother's house in London to live. After she had gone I felt terribly alone and vulnerable.

Then a drug dealer moved into her flat, and addicts and other dealers began to come and go at all hours of the day and night. One evening I was awoken by a loud banging on my door. I walked to the door and shouted, "What do you want?"

"Do you have a ladder I could use?" a man's voice said.

"No! Now go away or I'll call the police."

He walked away, but no sooner had I gotten back into bed than I heard someone climbing up the drainpipe outside my bedroom. A moment later there were footsteps up on the dealer's balcony, and then the sound of breaking glass, followed by a lot of shouting and fighting. I lay in my bed and simply waited

for the ruckus to fall silent. I wouldn't call the police for fear of repercussions.

I hid knives all around my flat in case someone tried to break in and assault me. I was no longer going to play the victim. When I walked to my mother's, sister's or friends' homes, I wore a hoodie and trainers, carried no handbag, and placed a long-bladed knife inside my sleeve. I also enrolled in jiu jitsu classes to learn street fighting, weaponry, and to build my self-confidence. Or, more accurately, learn how to quickly maim someone and *run*.

A few months later I met a man named Chris at one of my friend's parties. Standing six foot two inches tall, with blond hair and blue eyes, he worked in the city and was also the bassist in a heavy metal band. We hit it off immediately, and soon became inseparable—so much so that he moved in with me.

For the next two years we lived together, and it seemed perfect. Like me, he had experienced a horrid childhood, so we understood one another. We did everything together, we went everywhere together. He told me how much he loved me, and that he would never hurt me because I was the perfect woman for him. As for me, I felt that Chris was the first man I could trust completely. We both thought we would be together forever.

I was 100 percent supportive when Chris decided to give up his job in the city and concentrate on his music, as his band was getting regular gigs and they wanted to give their art all their energy. I often attended their performances and sat in on rehearsals. But one Saturday afternoon when Chris's band was going to play, I developed a terrible headache and told Chris I wouldn't make it to the show. He asked me if I was sure. I said yes, and he kissed me goodbye.

After a few hours' sleep, I woke to find my headache gone. I decided to go to the gig after all and surprise Chris; that would make his night.

When I strolled into the club, Chris was on stage doing a sound check. He saw me and a startled look passed over his face, followed immediately by a forced-looking smile. Puzzled, I bought myself a drink and went to say hi to the other band members. I could tell that they were thinking *What's she doing here?* Chris disappeared from the stage, and I spotted him near the glass door at the club entrance, talking to a blonde woman. I strode towards them, and Chris's eyes filled with fear. He was trying to hand the girl a bunch of keys. "Go," he said to her. "Just go."

I halted in front of them. "Who's this?"

"Who's *this?*" the blonde asked at the same moment.

I was shaking all over, but spoke to her in a controlled voice. "I'm his girlfriend."

"No, *I'm* his girlfriend!"

Clearly this girl had no idea what was going on, but I started to get angry at her anyway. "*I* am his girlfriend; he's lived with me for nearly two years!"

She began to tell me about their relationship. I didn't want to hear it. I wanted to talk to Chris, not her. "Can you please just leave?" I demanded.

"No." She continued with her saga.

I interrupted her again. "Can you just *leave?*"

When she kept talking, I shouted it: "*Can you please just go?*"

But she would not go! She took Chris's arm in a possessive grip. That did it. I punched her in the face so hard she flew through the double glass doors and landed outside on her back.

Two of the club's bouncers grabbed me, but I managed to clutch Chris by his clothes and drag him with me as I was thrown into the street. I dug my fingernails into his face, screaming, "How could you do this to me?"

He hung his head. "I'm sorry. I made a terrible mistake."

"I hate you! I fucking hate you!"

He had nothing else to say. I told him we were over; that he was to come to my flat the next morning and get his stuff. Then I stormed off and caught a bus around the corner. I couldn't stop shaking. I sat there with people staring at the black streaks my mascara made down my face. I didn't care. I was in shock. The man I trusted complete had ripped out my heart and thrown it into the trash.

At home I took a handful of sleeping tablets and waited for sleep to rescue me from the unbearable pain. Meanwhile I vowed that I would never again give my heart to anyone. People were, without exception, despicable. From now on I would remain cold and distant—with everyone.

Every time Chris came around to collect more of his stuff, or found an excuse to call, he begged me to take him back. Each time, I said, "No." It was not easy. I still had feelings for him. But what he had done was unforgivable—and if he'd done it once, he'd do it again. It turned out I was more right than I thought; later I learned that he had cheated on me with *six* different women.

One Friday afternoon I received a call from a friend called Dan. He asked if he could hide at my flat for a few days, as some people were "after" him. I was more than a little reluctant, but finally gave in.

When the knock came at my door, and I opened it to the

sight of Dan, his face sliced like bacon above a blood-drenched shirt. "Too late," he said. "They already found me."

I dragged him inside, soaked his shirt in cold salted water, and bathed and dressed his wounds. Although I didn't want to know the details, he told me that "they" had stabbed him all over with a utility knife as a warning not to "mess with them again." Next time they would use a real knife. Dan asked if he could stay over for the weekend and sort himself out. It was a request I could hardly refuse, but I was very much relieved on Sunday evening when he left.

It seemed that almost everyone I knew was a user, abuser, taker or manipulator. People lied to, cheated on, and stole from others at will. I only had one true friend, Jane, whom I had met when I was sixteen and she eighteen. She was the only person I could trust but I couldn't tell even her how my mind was beginning to be overpowered by dark, morbid thoughts.

Late one summer's afternoon I swallowed an overdose of Phenegran and sleeping tablets. I lay down on my shitty bed in my shitty flat in my shitty neighborhood, full of shit people and waited to die. There was no other option; death was the only answer to my problem, which was now obvious: I was simply not meant to be in this world. The time had come for me to opt out, to close my eyes forever and end this incessant distress.

I have no idea what time I awoke to the banging on my window. It could not have been too long after I swallowed those drugs, because I was able to walk to the front door, let Dan in and talk coherently to him. He told me he had dropped by to take me for a drink, to thank me for looking after him. I tried to refuse, but he simply dragged me out of the flat and into his car. I did not have the strength of mind or body to resist.

At the pub, Dan brought a pair of drinks over to our seats. "So, what's up with you?" he asked, looking at me with troubled eyes.

"Nothing," I said. "I'm just really tired."

"Are you sure? You don't look . . . "

Then the world went black.

I tried to focus on the nurse. She was shouting something. *Wake up*. There was also a doctor there, propping me up with pillows. Or so it seemed. I wasn't sure if I was dreaming or was actually in a hospital emergency room.

Either way, all I wanted was to be left alone so I could go back to sleep forever. I tried to close my eyes. "Oh, no," the nurse said sternly, "we can't have you falling asleep now, can we?"

But that was exactly what I wanted, couldn't she see that? He kept asking me questions that made no sense. Again and again I tried to curl up, and again and again the nurse or doctor would prop me up and shout at me. Why couldn't they just leave me alone?

Suddenly I saw my thighs propped apart by a metal basin with a fat brown rubber tube hanging down into it. And then I was vomiting, and it was as if my mind rushed back into my body. One by one my five senses switched back on; it was indeed like returning from the dead.

The nurse took away the tube and basin. "Back in the land of living, are we?" she asked, lip curling. She and the doctor snapped off their latex gloves and walked out of the room without waiting for me to respond, as if I had, in fact, died. I sat there like a contaminated rag doll that had been thrown from person to person, but that nobody wanted to catch. After signing some paperwork, I was released.

Not one person in that hospital asked me what had driven me to such an extreme act. Not one.

One evening not long afterward, I sat in my flat with the TV on while I sketched aimlessly in a pad. Not really drawing, just making sharp doodles, spikes and patterns. I couldn't really put my mind to anything, including what was on the TV.

But as the program ended and the credits rolled on the screen, the names were accompanied by a piece of music so exquisitely beautiful that I stopped what I was doing. Goosebumps invaded my body and tears of pure emotion trickled down my face. I was listening to a sublime perfection that elevated my soul to a higher place. A place I had never been to before. A place that made me forget who I was, and where I was. It was Mozart's *Laudate Dominion*.

And this music demonstrated to me that despite all the horror in the world, there was beauty, too. *Something* lovely I could touch . . . *something* I could hold on to.

The Self-Portrait

The very next day I went to a record store and bought tapes of Mozart, Beethoven and Tchaikovsky. I spent the next few weeks all alone, listening to transcendent, heavenly sounds that haunted me with their absolute beauty. They restored my faith in human nature a bit, for surely if men could compose such music, there must be hope. I was so inspired by these artists that I began to draw again, a pleasure I had given up as pointless when I left home at the age of sixteen. I drew portraits of film and pop music stars—James Dean, Cary Grant and Jim Morrison. Sometimes I drew animals—cats, panthers, tigers. Or I drew scenery—beaches and mountains. Sometimes I drew all through the night, enjoying the music, the peace, and the solitude.

The solitude ended in March of 1984, when a mutual friend introduced me to a tall, handsome man named Greg. Greg lived in rural Staffordshire, was twenty-two years old and ran a company promoting bands up and down the country. We started dating,

and he took me to places I had never been before, like Oxford, Cambridge, Bath and Stratford-upon-Avon. Beautiful places full of history and culture—a far cry from the hole I lived in.

Before long I began to feel my happiness growing, and that scared me. I didn't want to feel happy. I could not trust happiness. For happiness I would *always* pay a price, because clearly I did not deserve it. The only way I could protect myself from that price was to stay alert and keep an emotional distance from anything that brought me too much joy: like Greg.

On Christmas Eve I opened my front door to Greg, who kissed me Merry Christmas and began carrying armfuls of bags into my flat. They contained food, drink and presents. He told me to wait while he went back to his car. "What are you doing?" I said, laughing.

"I'm bringing Christmas to you!" And a few minutes later he dragged a seven-foot Christmas tree and a box of decorations into my lounge. I stared at the gifts with mixed feelings. For me Christmas evoked memories of extra arguments and fighting along with loads of additional domestic chores, but Greg's enthusiasm was infectious.

As we hung ornaments on the tree, Greg relayed stories of his childhood Christmases. His father would make sleigh marks in the snow, and sprinkle around half-eaten carrots. His mother would leave a half-filled glass of brandy and a half-eaten cookie by the chimney breast for Santa so that he could re-fuel as he delivered wonderful presents under the tree.

As Greg spoke, I felt tears streaming down my face and hurried to the bathroom to fix my face before Greg noticed. I felt stupid; what the hell was wrong with me? Why should I be feeling emotions that I neither understood nor wanted?

The same sort of conflicted anguish happened the first time Greg told me he loved me. I was rather shocked and didn't answer him immediately. He was visibly upset so I said, "I love you, too" because I felt obligated to do so and couldn't stand to upset him any more.

I truly wanted to love him back, but I knew that any "love" between us would be doomed. Once again my fear of being hurt overrode my desires. I had devoted too much time and effort to building my defensive wall to let any man break through it.

One evening Greg telephoned me to chat before he left for London on a business trip. I was pre-menstrual and emotional and tried not to cry, but the more he asked if I was all right, the harder I sobbed. At the same time, I assured him that I was fine; it was just "that time of the month." Finally we said our goodbyes.

Half an hour later, my doorbell rang. Greg stood there, smiling. "What are you doing here?" I gasped. "You're supposed to be going to London."

He stepped in and hugged me. "I just had to come and see that you were okay."

"I—I'm fine." I wiped my eyes. "Thanks, but I'm fine. Really."

Once he was certain I was telling the truth, he kissed me and drove off. I walked back into my flat, confused and stunned. *Why did he come all of this way to see if I was okay, and not have sex with me?* Was it possible he really *did* care about me as a person, a human being, and did not want to take advantage of me in my moment of vulnerability?

I felt overwhelmed. I had once read that in order to love someone else, you must first love yourself. So how could I ever possibly love another person?

As the months passed, my feelings for Greg became more intense. And the more they grew, the more paranoid I became as I waited for the day Greg would do something horrible to me.

I also feared for my mental state. Every month, about two weeks prior to menstruation, I would feel incredible tension build inside my body, especially in my neck and inside my head. My skull felt like it had to explode in order to let out all the pressure. But since it couldn't explode, I found release in crying bouts. And when I say "crying," I mean hours of sobbing.

One day after an argument over something so trivial I can't remember what it was, I punched the walls until the pain caused me to stop and cry. Greg held me tight. "What's wrong with you?" he asked, over and over.

"I don't know," I answered, over and over, and wailed in his arms for what seemed like hours. He told me later I sounded exactly like a wounded animal.

Another time, after an argument about me not trusting Greg, I stormed out of my flat in bare feet and ran as fast as I could through the fields until I came to a railway embankment. There Greg restrained me again, holding me until I released my anger in a deluge of tears.

Menstrual cycles might have been the triggers for these outbursts, but the underlying cause was much more complex than that. This man loved me, and I did not *want* him to love me. I was not worthy of love. Worse were my feelings for him. I *really* didn't want them. Yet here I was, falling in love . . . and resenting it. I was actually angry at him for loving me.

On top of that, Greg's love for me and the love within his family forced me to acknowledge the extent and depth of my own abuse. I didn't want him to judge and abandon me because of all that had happened in my life—things I considered to be

my own fault. So I didn't tell him about my nightmarish past—just "low-level" stuff that I minimized and sanitized. "Yeah, Mother used to be really angry and sometimes give us a good hiding when we deserved it."

The following Christmas, Greg and I shared a wonderful dinner I had spent the whole day making. But then the argument began. Again I can't remember what it was about, although I suspect the subject was, again, my not trusting him. I started hitting him so hard that he finally had to protect himself. Then I threatened him with a knife, which he managed to take off me. In an explosion of fury I lifted the entire table up and threw it, causing everything upon it to smash on the floor. I then bolted through the door and ran off into the night.

After Greg retrieved me—again—and my sobbing subsided, we talked for hours. Yes, I knew something was wrong with me; yes, I knew I needed help. I had already been to the woman's hospital, where I had talked to a doctor about my outbursts, my desperate need to cry, and all the other symptoms I was experiencing. She'd given me a supply of hormone pessaries (internal medication) and some charts on which to keep track of my weight, diet, sleeping patterns and mood. She'd also suggested that I take herbal remedies, such as evening primrose oil, and monitor my mood swings two weeks prior to every menstruation.

After Greg left, I sat there, upset and confused. Why was I behaving this way? And why was it getting worse? I knew I was in pain and had mental issues, but I didn't know why. I could not explain it in words: not to Greg, not to the doctor, not to anyone.

So I took out my sketch pad and pencils. Maybe I could express it in this way; show Greg exactly how I felt. I would

draw a self-portrait. I started with an eye, my right eye. I always start portraits that way. I can see the truth in that particular eye, the one that cannot lie. It is the emotional epicenter of a person, the only part of the brain that you can see. Whenever I meet someone for the first time, I always look to the right eye first—and within a split second, I can tell not only how good or bad they are, but on what level. This is not something tangible; this comes from self-preservation. This is pure instinct.

I carried on drawing, letting subconscious impulses work the pencil. There could not be any logical thought applied to this drawing. It had to come from deep inside.

On the third night I completed it, pinned it to my wall and studied it. It depicted my face and neck viewed head-on, the eyes blue and bloody red, the remainder mostly stark greys and blacks save for thin red veins. The left side of my face looked cut and scarred, but on the right it was much worse: the skin flayed away entirely to reveal a hidden structure of tubes and nodes—things not found in any anatomy book. I did not understand that I was expressing not my face so much as my pain, the trauma and damage of abuse. At the time, I only saw the drawing as confirmation of my mental illness.

For this reason I did not tell anyone, even Greg, that it was a self-portrait. Greg's opinion was that it was disturbing but brilliant; "It would make a great heavy metal album cover."

When Mother saw it, she said, "You must be evil to be able to draw something like that."

And when I showed it to the doctor at the women's hospital, she asked me if I suffered from migraine headaches.

By this time Greg and I had been together for over two years. We were inseparable, so despite my fears we began talking

about living together. He hated the area where I lived, and was constantly concerned for my safety and well being; rightfully so. Late one night after I left my friend's house and was walking home, a drunken man stumbled up and tried to grab hold of me. I told him to get away, and crossed the road. He followed me, calling, "Allison! Allison!"

"I'm not Allison, so piss off!" I shouted.

Again he tried to grab my arm. "You're comin' back to my place," he slurred.

I let my knife slide from my sleeve into my hand—then kept it there, while I used my other hand to push him hard in the chest. He tumbled backward into a hedge, and I ran off before he could recover. Knife in hand I hurried home, glancing behind me constantly to make sure he was not following.

On another night, again while walking the short distance home from my friend's house, I stood waiting for the traffic light to change as a main road junction. A lorry cab sped down the hill, then squealed to a halt right next to me. The driver stared out at me and smiled. I knew that predatory look too well. Skirting the rear of the cab, I walked briskly across the road. At the same time, the cab driver made a U turn inside the junction, bringing his car around to face the road that I was on.

"Fuck, fuck, fuck!" I repeated to myself, walking faster. There was no other traffic or people around; it was just me—and him. I began to run.

Behind me, the cab's engine roared and the gears changed as the vehicle raced toward me. I realized I was not going to make it home so I darted into someone's garden and crouched behind a hedge. For once I considered it a blessing that there were no street lights along that lane. Holding my breath, I watched the cab cruising along slowly, the driver looking for me. I decided

that if he stopped the cab again I would start screaming and knocking every door I came to, until someone woke up and helped me.

Fortunately, after a while the cab drove off. I waited a while, then, when I was positive he had gone, I ran home. I was shaking as I bolted my front door, and I spent most of the night staring out my kitchen window, just in case.

But even if leaving my squalid neighborhood sounded terribly inviting, I was surprised at Greg's determination to get me out of there. One afternoon he came bouncing into my flat, documents clutched in his hand.

"What are you up to?" I asked, laughing.

He held out the papers. "Have a look at these and pick the one you like best."

I flipped through the documents: estate agent photographs and details of houses available for purchase. I looked up at Greg, my mouth gaping. "Oh my God, are you serious?"

He smiled. "Never been more so!"

My eyes went directly to a small railway cottage set amongst a row of ten. "That one!"

"Okay, well, I guess I'd better buy it for you then."

I cried and laughed with excitement, but didn't believe this dream was real until we drove to the house and met the estate agent. The home was situated in a rural village not far from Greg's parents' place. The interior proved to be horrid and gloomy, but I knew I could make it cozy and beautiful.

Within two months we moved in: one of the happiest days of my life. I began to renovate the place. Greg's band-promotion company had collapsed the year before so we started our own business together, selling fresh farm produce direct to the

customer from our van. I became "countrified," wearing dungarees and Wellingtons, and growing my own herbs and other plants to sell. It was idyllic. I was in my element.

But although I felt content, calm and fulfilled as never before, something confusing and scary still lived deep inside me. It just refused to go away. I still experienced dreadful mood swings; still freaked out a lot. Still cried rivers . . . *still* couldn't bring myself to trust Greg.

Yet overall, I was in a much better place. The first time I walked to the village alone I took care not to make eye contact with anyone, just as I had done all of my life. I strode along at a sharp pace that made me stick out amongst all the smiling, laid-back local people. When I heard one of them say "Good morning" or "Good afternoon," I was freaked out. *What do they want from me?* I would think. *What are they going to do to me?*

I had to adapt to this extreme way of life; a task that for me would be an absolute pleasure. I had been dragged out of Hell and placed gently into Heaven.

Abigail: The Defining Moment

The moment I lit my first cigarette of the day on the fifteenth of November 1987, my stomach began to heave. I knew instantly that I was pregnant.

The next morning while Greg was at work, I sat on the end of my bed, waiting for the test strip to turn blue. I knew it would. I had come off the contraceptive pill the year before, as I had experienced visual disturbances and migraine headaches. Despite the fact that we used other contraceptives, this particular occasion had been an early-morning "slip-up."

Still, I was in denial. I had never wanted children; I didn't have a maternal bone in my body. So I paced the floor, especially anxious because smoking was out of the question. Finally the two minutes were up, and I looked at the ring. Oh! It couldn't have been any bluer!

Distress swamped me. I had a life growing inside of me—I, a woman who lacked the capacity to love herself or any another person. Although I would never consider aborting this new

life, how could I possibly give birth to it and be expected to show it love? I burst into tears, wrapped a duvet around my shoulders, and clutched my pillow. I stopped thinking. My mind deserted me, leaving my body to face this devastating blow alone.

Greg came home from work early to find out the test result. He looked at me with raised eyebrows. "So . . . you are then?" I blubbered incoherent drivel. Greg understood what that meant, hugged me and assured me that everything would be all right.

I was miserable and anxious during the long dreadful months that followed. The only time that I felt any pleasure was when I bathed, and saw my baby moving around inside me. I would touch her through my skin. I knew she was a girl, right from the start. I didn't need any scan; my instincts told me so. I named her Abigail, and decorated her nursery accordingly.

On Sunday the fourteenth of August I went to the loo and noticed I was bleeding slightly. Panic set in. I called my midwife, and as she examined me a large amount of blood flowed out of my vagina. This was not normal show. I was taken immediately to the delivery room at my local hospital, where they broke my waters and administered oxytocin to speed up my contractions. The placenta had torn away from my uterus wall, and my baby was in distress.

Greg had been sent to the hospital restaurant to eat. As he stepped back through the door to my room, I said, "Please get the midwife."

"Why, what's wrong?"

"The baby's coming."

He smiled gently. "No, it's not. The midwife said it won't be for a while."

"Don't tell me when my baby's come out; she's coming out now!"

He shot off down the corridor.

At three thirty-five in the morning, the midwife placed a beautiful baby girl onto—and into—my heart.

I should never have worried about being a mother. As I looked into my daughter's eyes, and she into mine, I was saturated with a sense of protection and pure, absolute love. At the time I did not realize that I was holding a bloodied angel, a beautiful angel . . . who would save me from myself.

Although I was engulfed by many different emotions, my first priority was to look after my baby. It was a daunting matter. For one thing, as a victim of abuse I had to deal with the niggling fear that despite my love for my daughter, I might end up abusing her eventually. On a more immediate level, I lived in the middle of the countryside miles from my family and friends. Greg was hardly ever home, as he now had two businesses to run: the farm-produce round and a property development business we had started prior to my pregnancy. Although I had begun driving lessons before I became pregnant, I'd had to abandon them because I was so sick.

In other words I was totally alone with my daughter, with no female support to guide or assist me. I certainly didn't want my mother near my daughter. Greg's mother lived close by but she was an alcoholic so I couldn't trust her either. My sister had moved to another county far away. My best friend did come and visit sometimes, which was great, but she didn't visit often enough to be of any real help. The villagers were friendly, certainly, but in a socially polite way; we were still

new here and didn't know them well enough to be able to count on them.

In the absence of "live" help, I had to rely on baby books to deal with all the practical needs of a child. And there were plenty of them. For the first two and a half years, Abigail rarely slept. She was extremely intelligent, so I spent most days and nights carrying her around the house, showing her everything there to expand her mind and feed her senses. As a result I was emotionally and physically exhausted.

But there was another problem. I could not bear for my baby to be upset or unhappy. Every time she cried, for however minor a reason, I would become terribly distraught. Later, I learned that this was because I did not see crying as an infant's only way of communicating her everyday needs. For me, crying automatically indicated pain.

Not understanding this at the time, I had no tools to stop my anguish and distress from growing right along with my daughter. Nor did I have any to keep my deepest, darkest memories from following it into my conscious mind. I started to experience flashbacks.

The first one came when Abigail was about two years old. I was bathing her little body, a task that always made me slightly uncomfortable. Similarly, I felt uneasiness about changing her nappy and cleaning her private parts, but had always dismissed the feeling because I didn't understand it. But this time as I bathed her I experienced an emotional electric shock. I felt the hands of my mother's boyfriend Ron all over my own little body. Tears came quickly, so I rushed over to the toilet and turned my face away from my daughter while she played with her bath toys. I cried and blew my nose into some tissue.

"What's wrong Mummy?" Abigail asked.

I wiped my nose. "Nothing, sweetie, Mummy's just got a cold."

The next time it happened. I was tickling Abi with a feather duster as she ran around the room in her slippers. She was giggling and I was laughing . . . until she recoiled into a corner of the room, laughing. "No, no more, Mummy!" I froze as my little girl became me, and I became my mother: Mother holding a bamboo cane instead of a feather duster.

I ran to the bathroom and sobbed. "How the hell could my mother have caned and hurt a beautiful, innocent little girl? How could she do that to me? How could she *do* that?" It was beyond my comprehension. For me, assaulting a child was an iniquitous obscenity.

Two years later I became pregnant again. This time the choice was deliberate—Abi had asked me for a sister to play with, and I didn't want her to be an only child anyway. I couldn't bear the thought of her being alone when the day came that I would no longer be around. Greg wanted another child, too.

Still, she was rather disappointed when I told her that I knew it was a boy in my tummy. She pulled a face. "Sorry," I said, "Mummy's clever, but she's not clever enough to change that!" I named my unborn son Dominic, which means "Born on a Sunday"—which he was indeed.

This pregnancy was not as bad as my first one, except that Dominic remained upside down right up to the birth. Looking back, I should have refused to have a natural breech birth, but in my emotional vulnerability I allowed the so called "experts" to make all decisions and execute all procedures. All I cared about was the health and safety of my baby.

Dominic was born on Sunday the ninth of June, 1991, at

3:30 in the afternoon. Two pediatricians set to work on him instantly while he struggled to breathe and I had my legs up in stirrups, a needle in my spine and vomit pouring out of me into a bucket. He was bluish grey in color and I looked at him in dread, willing him to breathe, to cry.

He survived, although he had to be placed in the special care unit because he was unable to drink milk. This problem persisted; he would only ever drink enough to keep himself alive. He did not even register on the baby weight and height chart.

For the next two years Dominic lived under a pediatrician's care. No one could understand why he would not take any sustenance. They exhausted all possible tests, and blamed his chronic tonsillitis.

I knew better. I knew in my heart that Dominic himself was in part responsible. In addition to refusing to eat, by the age of seven months Dominic was deliberately hurting himself. He begin a tantrum that always ended up with him losing control completely, either bashing his hands against hard surfaces or head-butting the wooden floor. I could not leave him alone for one single minute for fear he would maim or kill himself. Once he stood on the edge of a chair and dived head-first into a tin of metal cars, splitting his nose open and cutting his gums.

All I could ever do was hold him tight and rock him while he lost control. Even when he bit my chest, I would not let him go. I loved him too much.

At the age of two he weighed only seventeen pounds. He still refused food, and would rather sip water from a puddle outside or from his own bath than have a drink from me. One time I told him I wasn't going to feed him anymore; he would have to get his own food. He knew immediately that it was a ploy on my part, so over the course of an entire day he would eat

one grape or a handful of cereal. It was like having an anorexic baby.

Just after his second birthday, Dominic had a tonsillectomy. The surgeon told me he had never seen such swollen tonsils. I held out hope that this explained Dominic's strange resistance to food, but a week later, though he was full of energy, he still wouldn't eat. So that ruled out the tonsil theory.

Two weeks later, during Dominic's regular check-up at the children's hospital, the doctor told me that my son's brain and bone development were slowing down. He wanted to conduct some tests. Notwithstanding all the terrible things that had ever happened to me, the worst hour of my life was the one I spent sitting on a bench outside the hospital waiting to find out if my son had leukaemia. I cannot relate the unbelievable relief I felt when I was told that the test was negative.

A child's birthday party seems an unlikely place to have an ugly epiphany, but it happened to me.

It was a glorious summer's day, and lots of mothers and their children were playing party games in the garden of the house belonging to the parents of Mandy, Abi's best friend, whom she had met at play group. I had become friendly with Mandy's mother, Alice.

Abi came skipping over to me and fell into my lap. She said that she was tired. I kissed her hot cheek and held her while I continued my conversation with Alice. A moment later Abi took hold of my thumb and, apparently in search of some kind of comfort, started to rub her closed fingers up and down over it.

Without warning, an enormous shock surged through me. In vivid detail my mind coughed up the image of my own tiny hand masturbating Ron's penis. I couldn't take it. Leaping up,

I ran indoors to Alice's bathroom, where I collapsed in helpless sobs.

I could sense that everyone had gone quiet outside. Then I heard the other mothers herding together and whispering. I didn't know what to do. I couldn't stay in the bathroom forever, but if I went back outside everyone would be able to see that I had been crying. In the end, though, I had no choice. I felt so embarrassed as I went back to the party. Abi was still playing games, and I didn't want to spoil her fun by going home, so we stayed until everyone else had gone.

While the children continued to play outside, Alice made me a cup of coffee and asked me what was wrong. I couldn't help myself—I told her about Ron, albeit briefly and without any graphic detail. Alice said she was sorry for what had happened to me, and we talked about what a terrible world it could be.

The following morning I received a call from Alice thanking me for the lovely present I had given to Marie. But I was not prepared for what came next: "I don't want you to ever come around our house again, or even talk to me at playgroup. I'm sorry, but that's how I feel."

My mind crawled back into the woodwork with the other insects. I felt humiliated, as well as guilty, that confessing my wicked sin to a decent, proper and respectable woman had cost my daughter her best friend. That I had soiled and tainted Alice's pseudo-happy existence with my disgusting filth. That I had been condemned and exiled me to planet shit, where I belonged.

Later that night, when the children were in bed and Greg finally came home, I told him what had happened that day. Then I went on to tell him the story of my abuse, although I kept it on a very low level. I said I had decided to go to see a

counselor, because I refused to pass my emotional baggage on to my children. I wanted to be forever free of this pain and distress; to feel normal and live a normal life.

He gazed at me, and I waited for him to reach out for me, to envelope me with his love and support. "So . . . " he said, his voice low and angry, "you want to shame this family then?"

Double-Edged Sword

In late December 1992, ignoring my husband's pride and negativity, I sought the help of a therapist. "I'm going to see a counselor, Greg, and there's nothing you can do about it!"

My strength came from my instinct to protect my children; They were my number one priority and I was doing this for them. I knew I could not go on like I had been, trying to live a normal, happy existence while continuing to experience emotional anguish. I had suppressed my abuse for too long, and now every time I looked at my daughter I saw myself, the little girl no one had helped or comforted. I had to stop hiding from my past. I had to go back there, take that little girl by the hand and whisper into her ear, "I'm going to get you out of here."

The first few therapists I tried were private counselors who did nothing more than magnify my trauma. Their reactions were emotional, judgmental and condescending. Although I was both disappointed and disheartened, I remained determined. I could not do this alone. There had to be someone who could

help me. Perhaps the National Health Service counselors were better trained and more professional. After I had a long chat with my doctor, he agreed that I needed therapy and arranged an appointment with a female counselor named Linda Evans.

She was just brilliant. Linda treated me like a human being, not a number or a hopeless defective. She also answered many of the questions I had. For instance, it was Linda who explained that Ron abused me far more than my sister because I was the quiet, compliant one, the one who could be trusted to say nothing to anyone. And it was Linda who explained that I became emotional every time I remembered my mother holding my hand while crossing the road because that was the only time Mother ever protected me.

Linda helped me piece together the scattered pieces of my emotional jigsaw puzzle. She could see the picture complete, whereas I could visualize only the separate pieces and, thanks to my fear of reliving the abuse, was unable to put them back together. She methodically analyzed and expertly grasped exactly what I was relaying to her.

Best of all, she actually changed my thought processes. I had always believed that everything that had happened to me was my own fault. This intensified my sense of guilt and shame, which in turn exacerbated my self-hate. A terrible, endless loop: hate, pain and distress, feeding more hate, pain and distress.

Linda made me realize that not everyone in this world was out to hurt me, after all; that there are good people who do good things. Although I doubted this to my core, Linda herself represented evidence for what she was saying: she made a career out of helping people who were in pain. She told me that in order to love and receive love, I must first learn to love myself. I had to find out who I really was, not what people had made me become.

I had to start from scratch. Throw out the cynicism, the mistrust, the assumptions, the unwarranted judgements about people. My current perspective on life was a crippled, inaccurate picture; I had to find a balance that would render me a whole person at last. I had to stop feeling guilty and ashamed of the part of me that had been abused and degraded. The things that had happened to me were not my fault, not my choosing. I was a product of circumstance.

I was so entwined in my own drama that I could not see it from any other perspective, so Linda taught me how to take a "helicopter view" of my past; I learned how to look at myself through her eyes rather than my own.

It was the most traumatic thing I had ever done: To go back to those squalid houses with Mother and Ron and the boys in the sheds; to that hideous dungeon in London. Going back to those places and reliving all that had happened to me took many stressful and painful sessions. I did an awful lot of crying as I relayed my past to this stranger in a confined room with just a box of tissues to soak up my tragic tears. But I did it for one reason: so I would no longer inflict my emotional baggage on my beautiful children in any way, shape or form. I intended to love, protect and nurture them freely, as any good mother should.

It was during these sessions that, with Linda's blessing, I decided to confront my mother with the truth about Ron. I faced her not directly but via telephone calls and letters, which I kept as evidence to show my adult children if they were ever to ask questions about their grandmother.

The following is my first letter to her, after a telephone call in which I told her that I no longer wanted her in my life:

Dear Mom:

After receiving your telephone call, I have decided to write to you to explain better why I don't want you in my life anymore.

First of all, you say that you are lonely, well, I will never be lonely, because I have two beautiful children whom I love and respect, and as the saying goes "you get back what you give." So ask yourself, "what have you got back mom?"

Or moreover, what did you give? You see, lonely people who have family, have usually been unloving, selfish and disrespectful to them, especially to their children. How else can you explain their situation?

I am not holding grudges, and neither do I hate you; I feel sorry for you. The reason that I do not want to see you anymore, is not just the fact that you gave me and my siblings, pain, hurt, no love, no protection, no moral standards . . . No nothing, but that even up until our last encounter, you still upset and hurt me.

How any mother could say that her own daughter should see a psychiatrist, when she herself is the cause of it . . . Is unbelievable!! And yes, I have to see a counselor—because of you! And she doesn't blame me at all for not seeing you, even she felt upset and angry for what you did to me!

Everyone else [my siblings] is too weak to tell you, what you are, and how they are deeply upset by you! They say nothing, yet, it's there, and they, unfortunately don't know what real love and respect are so they have no comparison.

Do you know, I remember being about four or five years old and crossing the street with you? And you told me to hold your hand to cross the road. And I said

"Mommy, your hand is so warm!" I broke down to the counselor, not knowing why this insignificant memory of you "not loving me" but merely protecting me just for a moment, meant the whole world to me! Don't you think that is sad? Or does it mean nothing to you? Just as I did. . . .

It's a shame that you didn't have that protection at "that" other time . . . Do you remember? Because Ann and I do, extremely vividly! [When Mother's boyfriend abused us in front of her.]

We also remember the time when we were little, innocent girls, giggling and showing our bare bottoms, like lots of children do and when you saw us as you emptied the tea leaves in the drain. You turned so nasty and caned our bare bottoms and we didn't even know what we had done. I was so scared of you my whole life!

And do you remember laughing about how sneaky I was, to pretend to cry, so that you wouldn't hit me so hard? Do you still find it funny—or do you find it unspeakable??

When my little girl is being told a bedtime story, and is being loved and kissed, she asks me whether you used to do the same to me. I say, "Yes she did" and I cry softly when I leave her bedroom.

I won't go on anymore about these incidents. They are just part of the whole spectrum of things. As I said, you are still hurting people, and are still jealous, bitter, selfish and disrespectful. So going to church hasn't helped you after all. You only have church friends, because they will forgive your sins . . . But then, they weren't your unfortunate children were they?

Finally, before I close, you are missing out on a loving family. Unfortunately my children don't have a

nanny, as I would love them to have. If ever I see you again, it would only be if you changed, and I honestly can't see that, unless you are strong and brave enough to see a counselor and acknowledge what you have done to me and my siblings and genuinely say you are sorry. If you do this, then we will welcome you with open arms, but if you do not, then I'm afraid that you will always be lonely.

Suzzan

This was her response back to me:

17th December 1992

Dear Suzzan:

Thanks for your upsetting letter. So sorry that you are hurt and bitter. I never realized you were so hurt, you see, it's not that I never give love to anyone in my life, especially men, they all want sex mainly, which most men want.

You are lucky, I suppose you have a man that loves you for yourself and pampers you. When I had your lot, no one fussed over me, and when I had John, I was stuck in a mother and baby home. Then I had to work full time in a factory till your dad decided to marry me. By then I was expecting Ann, so I know what a hard life is with no one to love me.

I talked with John and Nicholas about how I hoped that they didn't still have any hurt left from childhood, and they both said they were okay and that we have to live in the future, not in the past.

I now know Suzzan that you were affected badly by things and situations in the past, because I think that you were and are more sensitive than most peo-

ple, which I didn't realize. I do hope that you will get alright; I am praying that you do. I do love you lots and lots, please forgive and forget.

I phoned you hoping that we could be friends, but you chose not to be, you chose to keep my grandchildren from seeing me.

When Ann stayed with me last time, we had a great time, till she visited you, then she came back all miserable. Did you have a go at her . . . about your horrible mother?

If so, and she also hates me, then I can wipe her out of my life too.

My church friends do love me and take me for what I am, not a stuck up, shallow person like you, and Jesus loves me and has forgiven my sins. All have sinned and come short of the glory of God.

I hope that you will get your head sorted out and learn to forgive, as that would be part of your therapy, and I did say that, I was sorry to you on numerous occasions, but you won't accept it; you like holding on to your pain and your past . . . then everyone will feel sorry for you. I do love you and did love you, but I know that I had a terrible temper, and with a stupid husband, four kids and a blind father to care for.

I don't need a counselor; I have given my life to Jesus, so I am healed now. Perhaps you should get "born again" and all that hurt and pain will go. Anyway, I have reflected on your words, and you're right. I have given up my sins and I feel better. But I can't go back in life, I didn't know I have damaged you all. You must feel really terrible, if you feel that. I will pray for your mind, and I will pray that you will forgive me and let go of all the hurt you have inside.

I did not belt you two girls on your bottoms, as you told me. I would never do that, especially not with a cane, like you said.

And you haven't seen your brothers for ages. I know they have personality problems, but at least they are not down and outs, living on the street. John keeps his flat really clean, he is loving and cares about me . . . and I treated him the worst of all. You only see the worst in them, and it's so sad, no one is perfect; you might think you are but that's up to you.[1]

So I will close now, and I do hope and pray that one day we could be friends at least.

Lots of love,
Your mom xxxxx

P.S. I do hope that when your children grow up, they will question why you kept them away from their (nanny), their own flesh and blood.

The letters would be proof of her psychopathy, her contradictions, her denial of the abuse. Mother was an editing machine who chose certain events to remember while dismissing any that she would rather forget.

At first she completely denied her boyfriend's sexual abuse of my sister and me, including that which she had herself witnessed. Then she claimed that what happened was not really her fault because she had been drinking heavily at the time.

In these letters she describes how "sensitive" and "weak" I was in relation to the physical abuse she herself heaped on me.

1 Author's note: My older brother, John, is a severe asthmatic who had gambling problems. My younger brother, Nicholas, was a drug user, had anger problems, couldn't form relationships and has attempted suicide a number of times, including devising an electrical device for the inside of his mouth to electrocute himself. Once, the police picked him up, drugged up and wandering around on a motorway. So when they said that they were "okay" to my mother—I don't think so.

She claimed that she had been under a lot of stress at the time, with all her useless husbands; and besides, she had never hit us "that hard." There was clearly something wrong with my mind, she wrote; I needed to see a psychiatrist. "You're bitter and enjoy holding onto your pain in order to gain the sympathy from others," she wrote.

During this period, as she discussed, Mother became a born-again Christian, washing away all her sins on the instant. Jesus now loved her and had forgiven her, so there was nothing else to do. She would pray for my mind.

I told her I no longer wanted her in my life, or in my children's lives.

In return, she sent me a Mother's Day card I had given to her when I was seven years old. On the back she wrote: You are a hard-hearted, hateful little bitch. And don't bother coming to my funeral, when I pass on to the glory, to be with the Lord in heaven.

Regardless of what God did, I knew I could never forgive her. Not now. It wasn't because she had allowed her boyfriend to abuse me; it was because she had now placed herself beyond remorse or the need to face her own sins. She would never acknowledge her violent and psychologically abusive behavior. In fact, by deflecting past situations and behaviors onto me, she was in effect justifying her abhorrent actions. I was the "baddie"—not she.

Once I understood all this, I found closure with my mother. Contrary to what many people believe, one does not need to forgive to have closure. One just needs to weigh up the facts, learn from them, and go on to make one's life better instead of wasting valuable energy on past abuse and abusers.

I have not seen my mother in twenty years, and I don't

believe I ever will. However, I did recently receive a card from Mother, who is in her early seventies now. Since she does not have my address, my sister delivered the card, in which Mother stated that she is "getting on" and is often ill. She asked if we could communicate again, and wrote that she was sorry about her boyfriend abusing me. Her very words were:

I am very sorry for the past, but as God is my witness, I didn't know what was going on. (I used to work lunchtimes then).

I actually laughed out loud when I read the last line. So here she was, *still* lying that about not knowing the abuse was going on, now claiming that she had been ignorant because she worked lunchtimes!

I have not for one moment regretted severing Mother from my life. To my way of thinking, she didn't deserve to have me as her daughter.

During the period of my recovery sessions, Dominic was admitted to the children's hospital for two weeks because his health was continuing to deteriorate. Although he did not suffer from leukemia or any other known physical disease, his bones had stopped growing and his brain had stopped developing. I was devastated.

But to my shock, the first week that Dominic was in hospital, his weight shot up miraculously. It didn't take me long to figure out why: Dominic had fallen in love with a nurse named Sarah, his prime caregiver and therefore the one who fed him his daily meals. Dominic not only ate everything she set before him, but asked for more!

Unfortunately for me, at this time there was a lot of press

about the so-called Munchausen by Proxy Syndrome, several cases of which had been discussed in newspaper and magazine articles. This syndrome described how a parent—usually the mother—would fabricate or induce illness or injury in their own child as a form of extended child abuse, or to gain power and attention.

In this atmosphere it was inevitable that Social Services would become involved in Dominic's case. Without performing any kind of individual investigation, they simply concluded that I must be responsible for Dominic's health problems. Was I not receiving treatment for my own abuse? Had Dominic's health not improved instantly once he was hospitalized and no longer in my care? Had anyone witnessed one of the self-destructive tantrums I said explained his frequent bruises and other injuries? No? Well, then, I was clearly beating and starving my own child.

I cannot relay the desperate fear that clamped my head in a vice. Right or wrong, these people had the power to take away my children. They never interviewed Greg, he was always away working. I kept a lot from him, and just said that Dominic was having problems and not socializing with other children. Anyway I did not need to complicate my life further by having him interfere with his stupid opinions and drinking more alcohol because he couldn't cope with difficult situations. So the pressure was all on me.

Then a miracle occurred. I had returned to the hospital after picking up Abigail from school. As we walked around the hospital with Dominic, Abi asked me if she could have some hot chocolate from the drinks dispenser in the hospital waiting area. I took both children to the machine and bought Abi her chocolate. Much to my surprise, Dominic declared that he wanted one, too. The chocolate was far too hot to drink, so I

told him he would have to wait, and placed his drink on a windowsill. He protested and stamped his feet. Again, I told him again he would have to wait—and he threw himself onto the floor and melted into one of his massive tantrums. His screams attracted the hospital sister, who said in surprise, "Is that *Dominic?*" Smartly taking hold of his hand, she pulled him up and marched him back to the ward.

Abi and I followed. I was numb with shock; Dominic had never before behaved like that in front of anyone but Abi and me. As the sister placed Dominic in a cot he not only continued to scream, but began bashing his forehead against the metal bars hard enough to leave huge red lumps. I almost fell against the wall with relief that the hospital staff were witnessing this display of self-harm, because at least they could see that his behavior was of his own doing.

After that incident, Social Services provided Dominic a place in a small private nursery school with the hope that he would accept food from the staff and his behavior could be channelled into positive activities. He was also to see a psychologist named Dr. James.

During our lone session with Dr. James, Dominic clung to my body like a limpet. The doctor was a condescending man who pigeon-holed us right from the beginning. His built-in theories and preconceived opinions prevented him from identifying Dominic's unusual behavior as the activity of an extremely intelligent and obstinate individual. He judged me to be an incompetent mother who had been deprived of a good role model and who could therefore not parent my own son adequately. Somehow he failed to factor into this equation the existence of Abigail, a demonstrably normal, healthy, and happy child. Instead, in his infinite wisdom, he concluded that Dominic's problems

were all my fault. He said I was relaying my stress to my son, who was reacting by seeking attention. It was a good idea, Dr. James said, to place Dominic in a nursery. Thus concluded the session. No need for further appointments.

As I was strapping Dominic into his child car seat, I asked him what he thought of that man.

"I think he's stupid and boring," Dominic said.

I smiled and said, "So do I."

Late one afternoon I received a call from the head of Social Services asking me to bring Dominic in to see her "straight away." Panic grasped me once again as I sat in her office holding my son on my lap. She rose from her chair, approached Dominic and inspected his face, turning it one way and then the other.

"Why are you doing that?" I asked.

"Oh, the nursery rang me this morning and mentioned that he had a large bruise on his cheek, but I can see that it's only a prominent blue-green vein."

Although I seethed inside with anger and disbelief, I knew I had to remain calm and collected. Professionals seem to always associate verbal anger with emotional instability and loss of control even though it was my experience that the most evil of persons hide their anger beneath apathy or stoicism.

So I simply heaved a sigh, stood up and opened the door. "From now on," I said, "every time one of you asks me how things are with me and Dominic, instead of telling you how hard it is to cope, I'm going to just smile and say, 'Oh, everything's fine, thank you!'"

She looked shocked. "Well, there's no need to be defensive, is there?"

I looked right into her eyes and smiled. "Oh, there is every need."

And there was. One afternoon shortly after I got home after collecting Abi from school, I received a call from a young female social worker, Vivian Riley, who had been assigned to my case. She told me that one of Abi's teachers had informed her that she had "observed the child rubbing and scratching her private parts, so I'm telling you to take Abigail to a doctor to be internally examined."

I was so distraught that I began to cry. "This is ridiculous. The itching is caused by Abi's skin reacting to washing detergents; I've taken her to the doctors about this many times. He gave me antihistamine ointment to put on her for the itching."

Vivian Riley was having none of it. "I *strongly* suggest that you take your daughter to be internally examined by a doctor," she said.

This was a young woman who had told me she didn't care for the suburbs; she wanted to work in the city "where the action is." In her uncompromising tone I recognized the clear threat: if I refused her "request," she had the power to take my daughter away from me.

The following day, I reluctantly took my innocent five-year-old daughter to be examined by a male doctor (there were no female doctors available at that time). As I stood watching my little girl lie down, take off her panties and open her legs, I began to silently cry. My whole body shook.

Not only was I reliving my own sexual abuse by watching this man examine my daughter, but doing so in the knowledge that *I* was being accused of abusing my beloved Abi. I, who only wanted to be the best mother in the world.

The doctor jolted me from my painful thoughts. "She's probably allergic to fabric conditioner. It's a common thing, do you use it?"

My eyes widened. "Yes I do. Okay, I'll stop using it immediately."

Trying desperately to not show my tears, I dressed and took my daughter home. I called Vivian Riley, as she had directed, told her what the doctor had said and recommended that she phone him to confirm the diagnosis.

Then I called my counselor. The floodgates of emotion had opened, and the outpouring needed to be addressed immediately. Linda came immediately to my house. I wailed, I cried, I protested how I was being treated. I said that I had only ever been honest with everyone, yet here they were accusing me of abusing my own children!

As the social workers and counselors I dealt with should have known, abusers *never* seek help for their conduct, past or present—because they do not recognize the behavior as abusive. They consider the infliction of physical harm justifiable, a deserved punishment for whatever wrong they believe was committed. And sexual molestation? That's nothing more than a form of gratification, or a means to profit. Abusers would never *ever* contemplate, seek, or believe they needed therapy.

After Linda had done her best to calm me down and reassure me, and although I appreciated all of her support, I had to think. I was contemplating taking Dominic out of the nursery school when another event made the decision for me. In fact, it forced me to change our lives completely.

It was a letter. An eviction order that said I had four days to be out of my house.

16

You've Got to Act

I discovered that between the years 1991 and 1995, my husband Greg had deceived me about our serious financial problems in the hope that they would just "go away" or "get better."

The decline began with the recession in '91. Greg, who didn't like knocking on hundreds of doors each week by himself, had been selling farm produce wholesale rather than door to door. But as businesses began to collapse into bankruptcy, each defaulted on its incurred debts, which in our case ran into thousands of pounds. Our other business, renting rooms to university students, had also failed, this time because the university had purchased some high-rise flats from the council, enabling them to provide cheap accommodation for students. And because our houses were in close proximity to the flats, rendering them both unsuitable and undesirable, no one would buy them.

Greg told me none of this; he said he couldn't face telling me, and because he paid all of the bills, I knew nothing about the accumulating debt.

In retrospect, I should have known better. For one thing, Greg had been drinking more and more, but I told myself this was just a response to the normal stresses of running a business. A much stronger clue arrived a few weeks before the eviction notice in the form of two burly bailiffs who came to my home with a warrant of execution that enabled them to seize and sell our goods at public auction "for non-payment of council tax." I was in a terrible state as the men entered my home and proceeded to carry out inventories on my furniture and possessions. One of them told me that he was going to seize my car. I pled with him, telling him I needed the car because I had to take my son to the hospital regularly.

The man smiled. "Lady, I can take it and I will."

I looked into his eyes. "You're so enjoying this, aren't you?"

"No, I'm just doing my job," he said, and began calling a towing company. I asked him to please wait while I spoke to my husband, then called Greg. He assured me it was just a mistake; he had already paid the bills in question. I told him to tell the bailiff that. The bailiff insisted that they had not received any payment, and unless Greg came back immediately and paid the full amount due, the government would seize our possessions.

Thirty minutes later Greg arrived and settled the amount. The bailiffs left, and I broke down in tears. Greg hugged me and told me some story about the check he'd sent the council being lost in the mail. He assured me that everything was fine now; I shouldn't worry so much.

Another warning flag popped up a couple of weeks later. I was driving Dominic to school, and as I waited to turn off the busy road into the car park, I glanced into my rear view mirror and saw a small white van hurtling towards me. To my horror, the driver had his head down, oblivious to my presence.

Terror grasped me. In a few seconds the van was going to crash into the back of my car, which contained my son strapped into the back seat! It was too late for me to start driving, so I started honking my horn as hard as I could. The van's driver looked up about two seconds before impact, veered violently left, missed me and crashed through a wooden fence and into a tree. I was shaking so much I could hardly drive into the car park.

The owner of the nursery happened to be married to a policeman who happened to be standing at a window at the time, drinking a cup of coffee. He saw the whole incident take place. It turned out that the driver had been looking for a music cassette in the glove compartment, which explained why his head was down. I was furious that he could have injured or killed my son through his carelessness, not to mention that he himself could have been killed, but felt fortunate at having escaped unscathed.

A few days later I received a letter from the police department asking me to come in for an interview. It seemed that I had no insurance on my car.

When Greg came home that night I showed him the letter, and he said the insurance certificate must have gotten lost in the post and he had forgotten all about it. The next morning I sat in the police interview room with Dominic on my lap, feeling ashamed. I explained that my husband dealt with such matters as insurance, and I had had no idea that my car was uninsured. I was let off with a warning.

Following these experiences I started to open Greg's mail every day. I also searched his office for evidence pertaining to unpaid bills and debts, but to my relief found very few. (Years later, I discovered that he had kept hundreds of unpaid bills and court threats in a huge bag in the back of his van.) When I con-

fronted Greg with the evidence I had accumulated, he admitted that things had been going badly with our businesses, but he hadn't wanted to burden me with the information since I already had enough stress and worry with Dominic. I insisted that his decision *did* affect me; after all, I had just been cautioned by the police, and had bailiffs in my house. I said that if he'd told me the truth I would have stopped spending so much money, and would have written to our creditors to ask them to reduce our monthly payments. I would have worked part time to help pay the bills.

Greg disagreed; he insisted he had done the right thing in keeping the truth from me. After several hours of shouting and arguing, we agreed to put the houses (including our own home) onto the market. We would sell them and move to a smaller, less expensive house.

But it was too late . . . far too late; the eviction order arrived only a few days later. I read it over and over again. What was I going to tell my children?

Recent events had already churned up some of the physical symptoms of stress I knew so well: chancres, boils, eczema sores. I also suffered from the constant sensation I was choking, and kept pulling down the imaginary neck of an incredibly tight sweater. I experienced terrible heart palpitations that sometimes felt as if my heart was actually turning over and over in my chest. And now I knew why.

Although I had quit smoking several years previously, I bought myself a pack of cigarettes, lit one and sat in my bedroom next to an open window while I tried to think of what to do. One thing I knew for sure was that my children were not going to be informed of just how bad things were. Instead I sat them down and told them that we were all going on a big

adventure. We were going to move to the seaside, where we had had a wonderful holiday the year before. To my relief, this news made them happy and excited.

The next step was to put my emotions on hold and my plan into action. I had to be strong now, and practical, and sensible, because Greg had completely crumpled. I made endless telephone calls to explain to friends, family, schools and doctors, that we were leaving the area. I found a new home for our beloved cat, and sold as much furniture and other goods as I could. I called the place where we had stayed on our previous holiday, and booked a mobile home trailer for a few weeks. Finally, I packed the personal belongings and precious antiques we had acquired and could not take with us, and delivered them to friends and family to store for us until we got a new place to call our own. I then packed the clothes, footwear and other items we would need at the holiday campsite.

On the fourth day, we were ready to leave. As I walked through the beautiful house that I had lovingly restored and decorated, looking at all the things that we had to leave behind, I told myself to stop crying and reminded myself of the horrific day I had sat alone on that bench outside the hospital, waiting for Dominic's leukemia test results. My children needed all my assurance and strength right now. Their father had gone to pieces; I had to carry us all. I had to get us through this predicament.

Late that night, as the children slept in their cramped bunk beds in the tiny mobile home, I unpacked our things. As I looked at Greg watching TV and guzzling his third can of beer, I realized I had lost all respect for him.

The next morning I busied myself registering us with the local school, doctor and dentist, and searching the ads for jobs and accommodation. When I returned to the mobile home, Greg

was once again parked in front of the TV with a beer in hand. I asked him what he had been doing all day.

"Thinking," he said.

"Thinking? *Thinking?* It's no use thinking, you've got to act. We're going to run out of money soon; we both need to get jobs!"

"Perhaps I'll start a farm produce business here in . . . "

"You can't just start a business with no vehicle and no money, Greg," I cried. "First you have to find regular paid work and earn some money, or we're not going to survive!"

But Greg did not relish being an employee; he had always worked for himself.

Soon Abi started at the local school, and while Dominic attended the school's playgroup a few hours a week I searched for part-time work. Unfortunately Devon is a tourist town where winter work is scarce. I did manage to find us a winter rental in an apartment not far from the school, so we moved out of the mobile home. For income we had to rely on Greg's new business—once again selling produce out of the back of an old open truck he had scrounged up. But he sold hardly anything, so I showed him job advertisements for full-time employment. He simply turned away, refusing to work for anyone else. I loathed him for putting his own ego ahead of his family's basic needs.

As December approached we were so far behind on the rent that the landlord asked us to leave. Only a few days before Christmas I found a permanent flat, an upstairs conversion of the landlady's house. I had already begged Greg to go back to Lichfield to sell some of our belongings and ask his family if they could help us out financially until we got on our feet. He

said he would wait and go after Christmas, as trying to sell things or ask people for money during the holidays would be "pointless."

Christmas day filled me with incredible sadness. I could afford only a small chicken and some potatoes and carrots for our dinner, and a cheap frozen dessert. Worse, I had only ten pounds to spend on presents for my children. Still, for their sake, I feigned joy as I watched them feigning excitement as they opened their pathetic presents.

I didn't even know where our next meal would come from.

After Christmas we fell behind on our rent again. Now Greg *had* to go back to Lichfield to try and obtain enough money for us to live. Two days after he left, all that remained in the cupboard was a tin of Spam and three sprouting potatoes. Although the weather had turned bitterly cold, I turned off the electric fire.

Dressing the children in warm coats, scarves and hats, I took them with me to the public telephone box in the village and asked them to wait outside while I spent a few coins to ring Greg's father, Colin. To my shock, Colin told me he hadn't seen Greg at all. When I told him I didn't even have enough money to feed the children—his grandchildren—he told me that he didn't have any money, either. "I couldn't afford my own funeral if I died," he said.

I listened in disbelief. Here was a man who bought a brand new mobile home and Range Rover every year—in cash! Yet he said he couldn't help?

He told me that he had lent Greg lots of money over the years, and never got any of it back. "I'm not asking for Greg," I said. "I'm asking for your grandchildren." It didn't matter. He turned me down, and never sent us a penny.

I hung up and sat for a while working to stop myself from crying. Then I called the social security and benefits office and recited my story. They gave me a "crisis loan" number to call, and when I got hold of a woman there I was told to come to their office "with your husband's accounts books." I said I didn't know where the books were; they could be in someone's shed, attic or garage, or even back at our repossessed house. The woman said she was sorry, but they could not help us unless we had those books in order to prove our predicament was real.

Fighting tears again, I asked, "Why would I be asking for a crisis loan if I was not in such a dire situation?"

"I'm sorry, but we really must have those books."

"But . . . "

I ran out of money and the line went dead.

Grasping my children's hands, talking as normally as I could, I headed back to the flat. The strain of holding in my fear became so overwhelming I thought I would surely collapse during the long, freezing walk up the hill. But I didn't collapse. I couldn't. I had to be strong now, stronger than I had ever been before

The following morning, as I was getting the children ready for school, the landlady opened our front door and walked in without so much as knocking. I stared in shock as she told me that since we couldn't pay the rent, she would be showing the flat to a couple, and would I please be out while she did this? Also, we had to move out by the end of the week.

I lost control. "How dare you do this in front of my children? Couldn't you have at least waited until they were at school before barging in with this upsetting news?"

"I need to show the flat now. It's costing me money to have people living here for free."

"Greg has gone to sell our things. He'll be back any day with the rent money."

Finally she stormed off, shouting, "By the end of the week!"

On the walk to school I assured the children that everything would be okay. Then I kissed them goodbye, made my way to an isolated spot on the beach, found a rock to sit on, and sobbed for over an hour.

But crying did not solve any problems. As I walked back to the flat I wondered what I would do if Greg came back to Devon empty-handed.

Later that evening he did come back, and he did have some money. With enormous relief I took the overdue rent to our now-smiling, now-making-small-talk landlady. I put money on the electric meter and finally bought some nutritious food. That evening, after the children were asleep, I stared at Greg as he sprawled on the couch snoring in a drunken stupor. I realized he would never get a job. I could not rely on him; our future was up to me. Very well, I would work 24/7 if it meant that my children and I did not have to endure another moment of insecurity.

I dreamt about earning a living from my art. I had wanted to try painting for a long time, so I bought a cheap set of paints and canvas and began experimenting by copying famous works. I also bought a box of soft crayons, with which I wrote and illustrated a children's book about an unwanted dog that gets abused and ends up running away to the seaside. There he does something so good he is rewarded by being adopted by nice people who love him. Looking back, I was obviously replicating my own life in that story. I sent it to a few publishers, but got no response. I had better luck with some handmade greeting cards I sold in a local shop.

I was trying to make our lives better. I was really trying—and deep inside I knew that everything would be all right. Fortunately I didn't know how long it would take.

Lucky Number Seven

In early February, after a lengthy interview, I got a job as housekeeper for thirty-three holiday apartments in the village where we lived.

Even though I would have to work a month before getting my first paycheck, I felt great knowing there would soon be regular money coming in. The only problem was that I did not have a bank account and could not obtain one because Greg and I had been blacklisted by so many creditors. After being in financial trouble like this, it takes a few years before they will even consider you again for a bank account. My wages had to be paid directly into Greg's Building Society account—a financial institution that offers savings accounts and mortgages—which for one reason or another had not been affected by our financial woes.

My schedule called for me to work on Thursday evenings and during the day on Friday, Saturday and Sunday—which meant that Greg had to look after the children on those days. The income

was still not enough, so I got extra work cleaning private homes, and every Saturday night I cleaned the village community hall. Although the labor was grueling, and a far cry from producing paintings, at least it kept the wolves from our door.

Meanwhile Greg was still struggling with his business. Although he earned very little he managed to drink quite a lot. Whenever I questioned him about the money he spent on booze he would tell me he'd bought it on special offer, or that shop owners gave him free beer in exchange for a good price on produce. I didn't believe him but what could I do?

Most of the time, after I finished work I would return home to find Greg drinking beer and watching TV with the children. Even on a beautiful day Greg never took Abi and Dominic to the beach or the park. And nothing got done at home, no housework or cooking, unless I did it.

On Saturdays, after I completed my housekeeper duties I would go straight to the community hall and work all evening. I took tapes of Mozart and Beethoven along on my Walkman to keep me going. Because I refused to cry in front of my children, tears often streamed down my face while I cleaned and mopped the building.

One Saturday evening Greg appeared at the hall with the children and stood there for a while watching me clean the toilets. "I will never forget what you're doing for us, you know," he said.

I just stared at him. Because the children were there, I didn't reply, but I thought, *So then why aren't you doing it instead of me, or at least helping me?* But he didn't offer, and I knew he never would.

After living above our loony landlady for a year and discovering the rarity of permanent accommodation in the area, I

decided to apply to go on the council housing list. Our landlady, Mrs. Thomas, was driving me crazy. She complained about everything: the noise the children made while playing; anyone talking or laughing; the TV or music being turned up too loud. We walked on eggshells in our own home. Another advantage of council housing was the cost: our rent would be less than half that of private tenancies. Best of all, I had learned that there were many council properties scattered around, not all of them on huge, rough estates full of base people like the ones I had grown up around.

But when I told Greg of my plan, he cried, "Forget it! We'll never live in a council property!" He insisted that I withdraw my application. But I didn't. I ignored him.

On Dominic's sixth birthday I asked Greg to drive us to another, larger, seaside town where I could withdraw my money from his account. I wanted to take Dominic to the shops and let him choose his own presents.

We pulled up on the high street, Greg handed me his card and I walked to the ATM machine and typed in the amount to be drawn out. The machine told me there was only £1.50 in the account instead of £250.00. Puzzled, I repeated the action in case there was a mistake; the result was the same. As I walked back to the van, I saw a look of indifference on Greg's face . . . and I knew that he had taken out all of my wages. I opened the van door and took my seat.

"Why?" I asked. "Why did you bring me here and let me try and withdraw money you knew wasn't there?"

He remained silent, as did the children. I cannot remember exactly what I said to him as I took Abi and Dominic out of the van—something about his being utterly despicable.

I walked the children to the beach. As they played in the

rock pools I sat watching from a bench, hugging my knees and crying beneath my sunglasses. *How could he? How could he do that?* I thought over and over. There was no answer, only a rising wave of hatred and contempt—and great sadness for my little boy on his birthday.

In April of the following year I opened a letter from the council. It contained an appointment for a housing officer to come assess my situation. When Greg got home I informed him about it, and he grabbed my arm hard and pulled me into our bedroom. Shutting the door, he exploded into a rage far beyond anything I had witnessed in him before. He even swore, something I had never heard him do. "Telephone and cancel the appointment," he snarled, "because I don't want anyone from the council nosing into our private lives!"

I was shocked, but stood my ground. I was going ahead with the appointment, I told him, and there was nothing he could do about it—and furthermore, if I were offered a house, I would take the children and go there . . . with or without him.

A few days later, the housing officer visited our flat. After seeing that I had two children of opposite sexes sharing a bedroom, and listening to my story about our struggles, he awarded us a lot of points that put us high up on the waiting list.

The following month, Mrs. Thomas asked to see me in her office downstairs. She told me that she and her husband had decided to convert the house back to its original state and live upstairs as they had done previously. We had to move out by the end of July. I protested that she was being terribly unfair, as she knew that there would be nowhere else to rent during the summer season.

She didn't budge a bit. In fact she thought she was being

benevolent for giving us two months' notice instead of only one. We were about to be made homeless.

I immediately began to search for a new place to live. I scoured the ads in newspapers and shop windows. I asked everyone I knew or bumped into if they knew of any local flats to rent. By the end of May I was knocking on the doors of random large houses, reduced to begging the owners to consider renting rooms, or asking if they had a caravan we could rent. Everyone gave the same puzzled answer: "No, sorry."

I made an appointment to see the doctor. I had become so stressed that I kept making mistakes at work, and wanted something to numb my emotions so I could cope. After I explained my situation, the doctor nodded and told me he was not going to prescribe anything; I should just try and put everything on a "back burner." I staggered out of his surgery like a wounded animal on the road that everyone drove over again and again.

Back at the flat I found an envelope addressed to me on the floor. I opened it to find a short letter from our landlady, reminding me that we had to be out by the end of July—and that in the meantime she was increasing the rent from seventy-five to a hundred pounds, effective immediately.

I stormed downstairs and into her back garden, where she lay sunbathing. "How could you do this?" I demanded, shaking the note. "Why are you doing this to us?"

She took off her sunglasses and sighed. "It's well within my legal rights to increase the rent whenever I feel like it."

I thrust the letter into her face. "Yes, but is it *morally* right?"

She just raised her pencilled-in eyebrows and shrugged her tanned, sagging shoulders.

Later that evening, I told the children I had a really bad headache and had to go to bed early. I lay there listening to the sounds of chatter and game playing in the other room, and with every childish laugh I felt sadder. What was I going to do? I had no answers. No matter how hard I tried, I couldn't seem to make their lives better. I was failing them. I hated Mrs. Thomas, and I hated the apathy of everyone around me, including my own husband. Was there no compassion in this world? No sense of guilt or shame? Did people really no longer help others?

I did not sleep that night, and when Greg began to snore loudly from his belly full of beer, I went outside and sat on a step, smoking and crying softly.

The next morning I caught a bus to the next town to see the housing officer who had visited me earlier that month. I also wanted to buy Dominic some presents, as it was to be his birthday in two days and I had finally managed to obtain my own bank account again.

The day was dark and dismal, constantly drizzling rain. The weather suited my mood as I sat in the waiting area of the housing department. I stood there staring at a wall and thinking... absolutely nothing.

Finally Mr. Allen sat down in a cubicle and called out my name. I said a polite hello and sat down opposite him. Then I relayed what was happening in regards to the landlady, the increased rent, the fact we would be thrown out at the end of July. As I ranted on I was unaware that he was trying to stop me, until he finally raised his voice.

He asked me to wait a moment while he made a telephone call. He excused himself, walked into a back office and closed

the door behind him. I sat there staring into space until he returned.

When he sat across from me again he had a rather smug look on his face. Placing his hands on the desk, he said, "I have some good news: we found a house for you."

I stared at him, unable to believe my ears as he described a location in the adjoining village. It was one of only two council houses left in that village, and only the day before, its ninety-three-year-old tenant had died. The house was now available, and he was offering it to me.

I made him tell me the details again, just to be sure I was hearing right. He said, "We'll be contacting you in the next few days regarding your signature in accepting our offer of a three-bedroom house set within a large but rather unkempt garden."

I stood up, and in my overwhelming happiness hugged and kissed this bearer of the most welcome news. What a glorious day—the seventh of June, just two days before my son's seventh birthday. We were to move into our new house on the seventh of July, whose number was, in fact, seven!

I did not know which way to turn as I stepped outside Mr. Allen's office, so I just walked in the first direction I turned. As I passed people huddled beneath their umbrellas, or hanging their heads in the drizzling rain, I held my own head higher.

The Cemetery Bench

I could not contain my elation as I picked up my children from school. The moment we got inside the flat I sat them both down and said that I had presents for them. I handed them each a bag. Their smiles turned to puzzlement as they each took out a set of children's gardening tools and packets of flower seeds. Then I told them we were soon going to move to our very own house, which had a huge garden containing no flowers at all. So we were going to plant some, and make it beautiful. They shrieked in delight.

That project ended up taking took two full years, but it was worth all the hard work. Apart from planting flowers I did everything myself. After getting home from work I cleaned, cooked and did the DIY decorating and gardening. I did the shopping; I did the school runs and the doctor and dentist appointments. Greg spent his days trying to make money, and his evenings and weekends sitting in front of the television drinking beer. I felt like a single parent with three children.

In February 1999 I decided to change jobs. I had had enough of doing the work of two people. Although there weren't many options in the area, I now had a small car and was able to get a job with a care agency that required me to look after vulnerable old people in their own homes around the community.

The evening before I was to start my new job, Greg went out for the night to drink with some friends. I had asked him to please not be too late returning, and not to wake me when he did come home, as I had to be up at 6:30 A.M. When he hadn't come back by midnight, I tried calling his mobile. It was switched off. I went angrily to bed.

Within half an hour I heard the telephone ringing, and shot downstairs to answer it. It was Greg, although I could hardly make out his slurred words. He told me the van had broken down, and asked if I could pick him up. So much for my good night's sleep.

I woke the children and dressed them warmly, clicked on their seatbelts and drove to the location where Greg had said he would be. As I approached, a policeman flagged me down and asked me to be careful, as there had been an accident ahead.

My body stiffened with fear as I passed Greg's van, battered and stuck in a ditch, the rear axle torn off. It was then that I realized he had lied to me again. The van hadn't broken down; he had crashed it while drunk and run off before the police arrived.

I turned around and headed back towards our flat, fuming. Both Abi and Dominic began to cry. Wiping his eyes, Dominic said, "Mummy, please don't divorce Daddy!" His words echoed inside my head, because that was exactly what I was contemplating.

I put the children to bed and spent the rest of the night wide

The Rebirth of Suzzan Blac

awake, not knowing if Greg was going to call or walk through the door at any moment. I sat in the lounge, drinking endless cups of coffee.

But Greg neither called nor returned, and at 7 A.M. I set off for my new job. I tried my best to smile and chat with my clients over the course of a long and fretful day. About twenty minutes after I got home, the telephone rang. It was Greg, calling from the police station where he had spent the night after being arrested for drunk driving. He received a huge fine and a two-year driving ban.

That evening after the children had gone to bed, I sat down next to Greg while he was eating. "Because of Dominic," I said, "I'm not going to legally divorce you. But as far as I'm concerned, we are no more. From tonight, I will never sleep in the same bed as you, ever again. We are over."

"Yeah . . . " Greg mumbled. "Whatever."

I took off my wedding band, crushed it flat with a pair of pliers, handed it to him, and walked upstairs to bed.

In January of 2000 I started work on the first of what would turn out to be forty-two paintings depicting my life of abuse. This was something I had to do for myself. Despite the long journey I had been on, and the therapy I had had, and the amazing presence of my children in my life, I still struggled with a terrible burden of pain and anger. I knew it would be cathartic for me to purge and express my emotions in visible form, transforming the images inside my mind into something tangible. Something I could see and touch.

During my "flower and cute animal" phase, my chosen media had been pencil and crayon. Now I discovered oil paints, which were to become my only medium. Oil is exceptionally

mobile, and allowed me to blend and gradate colors to achieve the realism I sought.

The very first painting was of my mother. After I finished the canvas, I stared at it until a sense of revulsion and disdain replaced the indifference I had held for this woman for so many years. During that time I had kept my feelings in check because I had such conflicted emotions. Yes, Mother did do terrible things to me—but she was my *mother*.

Now I had placed my deepest and truest feelings about my mother on canvas, rendering her as a serpentine form with a gaping maw, insanely glaring eyes, and a clenched fist. For the first time I saw Mother in her true colors: blue to depict anger and power; red to represent pain. That was all Mother meant to me. Her portrait displayed no beauty whatsoever, no love. What stared out at me was pure hatred.

After that I decided to paint everyone who had ever abused me, and to depict how the abuse made me feel. I would become the photographer of my own life story.

When I finished "Madonna and Child" even I was shocked at what I had produced: the image of a mother poised to glee-fully devour her own child. The painting was extremely dis-turbing, rendered from pure emotion, without the intrusion of logical thought, boundaries, or any sense of right and wrong. This was exactly how Mother made me feel inside. This was my truth . . . and my freedom.

I continued to purge my pain onto canvas after canvas, draw-ing my soul through a whole spectrum of emotions: sadness for not being protected and loved; indignation at those who had hurt me; abhorrence of what they had done to me. There was also a sense of vengeance fulfilled. My abusers had once owned me but now I owned them—as paintings.

It took me four years to complete all forty-two canvases, because I painted only one at a time and turned my easel toward the wall as each one dried. I didn't want anyone, especially my children, to see these works. I knew that people would misinterpret them, and me, as evil and vile. Once each canvas dried I hid it away in a dark place, where surely such images belonged.

Greg, however, did occasionally see me working on the paintings—and sure enough always had a negative, unkind remark to make. "Why do you want to live in the past?"

Why do you want to hold on to your pain?"

"You enjoy being unhappy, don't you?"

"Are you still mentally ill?"

And the crown jewel: "You could really disturb your own children if they see these; don't you care?"

He made me feel so bad about what I was doing that I once again began questioning my mental health, so I also started painting flowers, animals and landscapes to prove (yet again) my emotional stability.

Ironically, many years later, I learned that Adolf Hitler had loved to paint flowers and landscapes. What does that say about the "psychology of art?"

"Stop it! Stop it, you bastard!"

"You don't know what he's like!"

"Leave him alone, he's just a small boy, and he will hate you . . . you bastard!"

August 28, 2000: the day I tried to stop a man from kicking his son on a path outside a cemetery. The day I decided to write the story of my own abuse to provide aid to other victims. *If I*

can help just one person before I die, before I myself am under-ground, then it will be worth it.

Fate had pointed me in the right direction.

In December of that year I read the book *A Child Called "It"*, by Dave Pelzer, who wrote about his own abuse. Inspired to send my story to the same publisher, I wrote a short synopsis, included a covering letter and some photographs of my paintings, and mailed it to the editor. A few weeks later, I received a letter from him which read:

> Dear Suzzan:
>
> I read your letter with growing melancholy that such inhumanity should be described outside of a nightmare; it's almost beyond my imagination. Your resilience and fortitude is an astounding testament to your character. That you have survived and grown into such a caring human being is remarkable.
>
> I'm sorry to have to say I can't publish your book. I fear it would be just too much for people. As time progresses and we publish a little more and then still yet a little more of the horrors that happen out there, then someday soon the "public" may be ready.
>
> Until then I wish you luck with you art which is extraordinarily powerful, and I wish you all the good things life can bring.

Although he had told me he couldn't publish my book, I did not feel despondent. This man was applauding me for who I was and what I was trying to do. That meant so much to me that I think I read his letter a thousand times that day!

For the first time in my life, I felt inspired and believed that what I was doing was purposeful and important. I didn't try

another publisher; I thought maybe he was right, maybe my story was just too horrendous to inflict on people but perhaps one day . . .

☞

Much to Greg's disdain I continued work on my personal paintings, even though I still felt really bad for creating them.

In November 2000, I happened to be watching a programme called *Newsnight* on BBC2 when they featured a report on a man named Colm O'Gorman. A survivor of clerical sexual abuse, in 1999 he had founded an organization called One in Four, which supported people who had been sexually abused. He was currently involved in the making of a documentary about sexual abuse, *A Family Affair*, which documented a father's incestuous abuse of his four daughters.

As I listened to this incredibly courageous man who not only spoke publicly about his own abuse but was a powerful voice for other survivors, I felt awe at his bravery and resilience. This was a man I could identify with.

The following morning I wrote a long letter to Colm, and included some photographs of my paintings. The following afternoon, I was outside doing some gardening when Greg stepped out the back door, holding the cordless phone towards me. "It's Colin Morgan?" he said, puzzled. I shook my head as I tool the phone; I knew no one named Colin Morgan.

"Hello?" I said.

"Suzzan Blac? This is Colm O'Gorman."

I was shocked. Not only had I sent my letter only the day before, I had never expected a telephone call in return.

As we chatted, Colm told me how amazing and important

my paintings were, and how he himself identified with them. I was so honored I could not reply.

Over the next few years Colm and I corresponded often, and I continued to send my images to him as I painted each one. At one point he intended to organize an exhibition of survivors' art, but due to lack of funds and resources it never happened.

Still, thanks to Colm's inspiration and moral support, I developed a level of determination I had never felt before. His encouraging words about my art gave me so much confidence that for the first time in my life I actually felt good about my work. I felt valid and worthwhile. His compassion and support were the catalysts that shifted me onto the path of courage to help other survivors.

He was, and still remains, my hero.

Later Colm would make another documentary called *Suing the Pope*, which documented his historic lawsuit against the Catholic Church. Colm also wrote his autobiography, *Beyond Belief*, and is currently the Executive Director of Amnesty International in Ireland.

During my initial correspondence with Colm, Greg suddenly had a change of heart. He took an interest in our communications and started to constructively comment on my paintings. In fact, years later he would say that he actively encouraged my art all along, and denied ever expressing any negativity.

But the truth is that I chose to take my own path. During the previous few years I had gained self-esteem and determination, and no one was going to manipulate or suppress me ever again. In fact, I experienced another defining moment: I decided that my life had been so extraordinarily bad that I was going to turn it around completely, into one extraordinarily good.

"The world shall know me," I told my children.

Art Is War

During the next six years I labored in many hotels and caravan sites, often taking my children with me during the school holidays while I cleaned. I was by far the main breadwinner of the family, regularly working sixty to seventy hours a week during the height of the tourist season. But every week, on my only day off, I would paint flowers and ocean views, not child-eating mothers, flayed heads, bloody bodies. Those works were done.

After completing the last of my "personal" paintings in 2004, I had locked them all out of sight. Creating the paintings had been cathartic, yet in the end they had not given me a real sense of closure. Perhaps nothing ever would. Perhaps I would just have to live with my pain and get on with my life the way people with chronic physical illnesses do.

So I painted landscapes and flowers; sold quite a few of them in local galleries and to people I worked with; and got on with my life.

But one day a woman who had bought three of my flower

paintings requested a fourth—another sunflower to match the one she already had. The day she asked me, something extraordinary happened. I desperately needed the money, but a voice inside my head forced my mouth to say, "No."

I was almost as astonished as my patron. It was like there were two halves of me. One cried, "Do it, you need the money!" while the other insisted, "Don't do it, you really don't want to paint another tree or flower; you hate this!"

"Why ever not?" my patron finally said.

Suddenly I realized the cause of my inner conflict, and the two voices became one. I smiled. "I'm really sorry," I said, "but from this moment on I will never paint for money or to please others; I'm going to paint only what *I* want to paint."

If she felt disappointment, I felt released. I went home and threw away all of my painting references for landscapes, seascapes, animals, trees and flowers. It was like being "artistically born again."

For the next few days I tried to think about what to paint. But nothing came into my head. Finally, one evening I grabbed a sketch pad and pencil and started to just doodle. This was how the idea for my first personal painting had come to me. Perhaps the trick was to *not* think. When I saw what my hand produced, I knew I was on the right path. It was no flower, certainly; no bunny rabbit. Nor was it the intensely private stuff of my personal paintings. But it was real in the sense that it represented how I felt about certain ugly aspects of the world. Ugly truths that needed to be forced into the light. This was not the sort of image that can be produced by calculation. Logical thought thwarts your true feelings and limits your creative boundaries as well as the courage to go beyond the barriers of acceptance and perceived normality.

That said, I nevertheless wanted to paint realism; I wanted

my figures and faces to have a photographic quality to them because that would render them *more* disturbing. And I especially wanted the eyes to confront the viewer and establish an emotional connection.

Juxtaposing horror with beauty was also my trick, for horror alone was not enough. I had to paint as beautifully as I could so that my images would be compelling yet remain etched into the minds of even the people who didn't want to look.

Visual images are the most instantaneous and powerful of mediums. People can choose *not* to watch a film or read about the abuse out there, but once they see an image, even for a second, it's too late to back away. I knew my true paintings would not be commercially viable, but I didn't care. I was determined to not compromise my artistic integrity. I would rather clean rooms every day than to paint for money or to appease those around me.

At this time I was working with a team of housekeepers at a large holiday site. One day I was introduced to a new girl, Lisa, with whom I would now be working. We really hit it off, and soon became firm friends. One morning while talking we got onto the subject of psychology and abuse, which prompted me to tell her about my history and the paintings that I had done. She took such an active interest that I decided to show her the photographs I had taken of my art.

She started looking through them the following day while we sat in her car. Without warning she put the photos down and began to visibly shake. "I-I need a cigarette," she said.

"What's wrong?"

"One of those paintings—'Tell Me You Love It'—it was like a slap in the face."

"I'm so sorry. I didn't mean to—"

"No, I needed it." She went on to tell me that after her own abuse she had dehumanized herself for so long she had forgotten what it was like to "feel emotion." Seeing my painting had stirred her memories and brought her emotions immediately to the surface. (Later she would seek professional help to aid her own recovery.)

I considered the reactions the photos had gotten from the few other people I knew well enough to have shown them to. After viewing them one woman just could not stop crying, and had to leave work and go home. I wondered if it was right for me to show anyone else these images if they led to so much pain and distress.

Or if that was exactly why I *should* show them.

In December 2007, I asked my daughter Abi, then twenty years old, to help me create a MySpace profile in order to display some of my art on the Internet. At first, to test the waters, I posted only a few of my more subtle paintings. I did not want to receive any of the negative or upsetting reactions I had already experienced.

We made the profile and almost immediately I began to receive terrific comments. Online, I had a gallery to the world. Getting such positive reactions incited me to paint even better and more prolifically.

This was my first significant step forward as an artist. Instead of the usual reactions from people I knew personally, I now had a mass audience and a clear understanding of how relevant my images were to them. Their messages and comments validated my quest to follow the path of my avocation. I was no longer painting only for myself—I was painting for those who could not express their own pain in words or images. I was a voice for

them, a release from their anguished silence. And the experience was as cathartic for them as it had been for me.

I could not believe how fast things began to happen, how many people were taking interest in my work. Before I knew it I was showing my art in Berlin, New York and California. I appeared in books, magazines, blogs and interviews. My art was even featured on an Australian TV show!

Over the next three years I gained a massive fan base, mostly in America, and I regularly received amazing messages from all over the world from people who identified and connected with my art. They thanked me for sharing my innermost feelings of pain, anger and suffering.

Inevitably there were also negative and cruel comments from people who called me "satanic," "evil," "disturbed," "fucked up" and even "attention seeking." Although I tried to dismiss these remarks, they upset me. These people were misinterpreting my art as gratuitous horror instead of works with emotional layers depicting abuse and its consequences. Many such people would accept the sanguinary works of religious artists such as Caravaggio, but not art like mine that is both contemporary and relevant to victims' experiences. My art is meant to appeal to those who can identify and connect with it, and thereby feel less isolated. In the realm of sexual abuse, just knowing that you are not alone helps tremendously. And realizing that what happened to you is not your fault aids in your recovery process.

Following are just a few examples of the messages I have received from people who feel touched and helped by my work. These are the people who matter; this is why I continue on my path. Survivors say that I inspire them . . . but the truth is, they inspire *me*.

"Your art speaks for all of us who have been abused and victimized. . . . Thank you for doing what you do."

" . . . I find your work inspiring. It reminds me that it's okay to speak out."

"You are such a strong survivor, and I love that you express this on the canvas. It's important for yourself –but also the perfect way to share/warn/ enlighten the world about sexual abuse and abuse itself."

"Thank you for sharing these things with us as your fans, Suzzan. Much of it seems so familiar to many of those who I've known have suffered in similar ways as you . . . "

"The moment I saw your work, I GOT IT in a second. My insides actually turned over. You don't even have to explain what your pain is about . . . as a woman and a rape survivor, I got it IMMEDI- ATELY."

"My boyfriend was violated in his childhood. Because of that, I ask myself everyday how can I help him with those feelings; your art has shown me how he might feel inside."

"I, too, am a survivor of abuse. I have never been able to express my lingering memories. You have assisted me in this endeavour. You are a GENIUS!"

"After I see your work I feel a sense of relief because I feel as though the emotion as passed through me. I feel like I'm able to accept everything and not let my fears control my life."

As I began to paint ever more gory and visceral images, I received even more attention, both positive and negative.

Often MySpace would censor or delete my images with the warning that if I continued to ignore their guidelines regarding inappropriate subject matter they would delete my profile. I could not understand this, as my profile was set to over-eighteens only, and I never added people, they only added me. Still, every time I posted a new painting, I was terrified in case they did what they were threatening to do.

I became known as the "Goddess of Gore," a title bestowed upon me by one of my fans and friends, Roxanne, who also started a fan-based profile on MySpace. One reason the title pleased me was that even as a child I had been chastised for producing visceral images, whereas my male counterparts were not. It was acceptable for boys, but not girls, to draw bloody battles or pictures of horror. Girls were expected to draw pretty things such as animals, fairies and flowers. This vexed me beyond words, so I was exceptionally proud of my new-found title.

Also, I knew that many people who suffered abuse turn to horror literature, images and movies, just as I had as a teenager. So being known as a great horror artist was most advantageous, as these were the people I wanted to target.

In November 2007, I made the decision to legally divorce Greg. I could simply no longer tolerate his behavior. He had attempted to suppress, control and suffocate me long enough, and now that Dominic was sixteen, I felt he was old enough to understand and handle the situation.

One evening as I was making dinner, Greg stood in the kitchen questioning my cooking methods and badgering me about my latest Doll painting. I looked at him and thought, *I*

cannot bear this man any longer. I couldn't even stand to hear him breathe.

I made a simple announcement: "Greg, I am going to divorce you."

He smiled. "Ha! Yeah, right. Is it that time of the month again?"

I screamed at him with such rage that he raised his eyebrows in the realization that I might be serious. He said, "So, how are you going to support yourself and the kids then?"

I told him that I didn't care if divorcing him placed me in financial hardship; I would rather live in a tent than spend one more day with him.

He continued to barrage me with questions and statements. "So how are you going to get me out, call the police so they drag me into the street?" And, "*You* can get out! You can leave, as you are the one who isn't happy!" He even said, "Maybe I should get Social Services around to look at your paintings. They would then know which one of us was mentally ill!"

His efforts to manipulate me into not going through with the divorce only succeeded in fortifying my intentions. The next day, I telephoned for an appointment with a local solicitor in order to begin divorce proceedings.

Greg left in May of 2008, and the divorce was finalized in 2010.

In February 2009 I held my first solo art show, a collaboration between the Strychnin and Resistance galleries in Bethnal Green, London. During the previous year I had worked on a series of large paintings entitled "A Basement of Dolls," depicting the sexual conditioning and exploitation of females. They were incredibly hard work; I painted five of them by render-

ing ten layers on each canvas—the equivalent of producing fifty huge paintings!

But the result was worth all the hard work. A large number of people attended the show, and it was wonderful to watch and listen to their reactions and comments. The McCarricks played during the show, and best of all, my children and two of my best friends were with me. We had a fantastic night, and although I was disappointed that I did not sell any of my works at the time, I am now delighted that I didn't! I now feel that I could never part with my Dolls, they are so personal to me. They are my "other" children.

In April 2010 I discovered that my MySpace profile had been deleted. I was so devastated that I posted the news on Facebook, and many people expressed their sympathy. It had taken me more than three years of hard work to set up my profile and establish my many contacts in the art world. I had cultivated and stored thousands of friends, wonderful comments, sentimental messages, and blog views of my writing and poetry— and MySpace had deleted it all in just a few seconds. I felt that they had violated my rights and denied other survivors my art as a facet of help.

A few weeks later, while I was still traumatized by my loss, one of my fans, Justin Burning, sent me a link to a Website that he had built for me after hearing about my deletion. I was gob smacked, and so overjoyed that I repeatedly thanked him for his overwhelming kindness. A Website meant that no one could censor or delete my art ever again, and it could now be available for the entire world to see—as it should be, untouched and intact! I no longer had to comply with anyone's guidelines. It was almost too wonderful to put into words.

Art *is* war, on many levels. As a survivor of abuse I feel that I have a moral obligation to help others, using a gift that I am incredibly lucky to have inherited. Years of secrecy and suppression have transformed my silence into screams of truth, freedom and vengeance; into images no one has ever seen before, or do not wish to see. Even many victims don't want to face the monsters that dwell inside their heads and will eventually devour their souls. My art brings these monsters to life. Other victims of abuse can see that I have fought my monsters and conquered them. And if I can, so can they.

To an extent I can understand why some people view blood, gore and torn flesh as merely gratuitous horror produced by sick individuals. But how else does one depict pain and suffering? How else does one purge anguish and mental torture?

I also understand that some people simply don't like to think about how other human beings are capable of doing such terrible things as were done to me and other victims of abuse. Well, they did, and they do. They are doing the exact same things to children every hour of every day, and it is my duty to expose abuse and abusers through art. My art *is* shocking, but then so is the subject matter. If I had seen art like mine when I was a child, I would have related and connected to it, and acknowledged and recognized my own abuse—because those images would have triggered my own memories. I would have identified with the emotional pain in them, and accepted that abuse isn't normal; that I had *crimes* committed against me as a child.

Maybe I have gone too far. Maybe I have crossed that severely uncomfortable line. And maybe my art *is* taboo to some. But I had to be uncompromising in style and content in order to project the truth about abuse and its consequences. I needed to hit people with an artistic sledge hammer rather than

gently tap them with obscure and tentative images. Images like that would not cause such an emotional impact or lasting resonance.

I also like to think that the term "Goddess of Gore" represents Athena, the Greek Goddess of (amongst other things) wisdom and war. Because of my personal insight and experience of abuse, my art *is* war. There is no art bloodier than mine. As a result I have had to fight: against suppression, censorship, deletion; against hurtful comments and messages. I have even received a court injunction against my art.

But that's fine. I fight to expose my abusers and bare my soul to the world. I fight to be recognized and respected. And I fight on behalf of other victims and survivors so that they no longer feel isolated, stigmatized and condemned by those who impose secondary victimization.

I will continue to fight to the death—or rather to my own death—in the hope that I may educate the timid, change minds, and help as many people as I can.

For that is my ultimate antidote to all of that is bad in this brutal—and most beautiful—of worlds.

Ars Longa

One day in 2009, I thought it would be wonderful for my son to have a piece of my art on his body. So I designed a tattoo for Dominic for his eighteenth birthday. I had also designed one for my daughter, Abigail, on her eighteenth birthday. (She chose her own image, which incorporated one of her eyes into the design.) Dominic's tattoo depicted a skull with a melting candle upon its cranium above the words *carpe diem*, which is Latin for "seize the day." I wanted the same tattoo as well, but with the words *ars longa*.

Dominic was delighted with my design. "Thanks Mom, I will wear it with pride." In fact, he was so happy with it that he paid for my tattoo, fourteen days later, as a gift for my birthday! We went to a local tattoo artist to have our inking done at the same time.

I asked that my tattoo be placed on my left shoulder, while Dominic had his inked onto his chest. Half-way into the work, Dominic had to have a break because of the pain. As he got up

to go outside and have a cigarette, I joked, "I didn't get to have a break while I was giving birth to you." He smiled and walked through the door. I think he hurt too much to produce a retort.

Charlie, the tattooist, had a fascinating parlor, to say the least. It displayed curios from all over the world—shrunken heads, skulls (some of them human), and a huge tank housing chameleons, those amazing lizards that change color and whose eyes rotate independently. I felt right at home there, because my house has similar characteristics (minus the human skulls and chameleons). I have many animal skulls, preserved animals in jars, fossils, a shark's jaw, box frames containing giant moths and scorpions, and living baby scorpions, as well as my paintings hanging all over my walls. You can imagine the looks on the faces of strangers, especially builders and plumbers, who come into my house.

"I know what *carpe diem* means," the tattooist said, "but what does *ars longa* mean?"

"It's from a Latin saying: 'Art lives forever . . . although the artist dies.'"

"Well, that's really profound, I like that!" He smiled. "I had better not accidentally add an 'e' on the end of ars then."

"Better not—or *you* will die," I said with a smile.

I loved the idea of the *ars longa* tattoo. I had designed it specifically to remind me that I must produce as much art as possible before I die—because apart from living through my children, I want to live on through my art.

I want immortality. I want to leave my mark in this world, and a reason to justify my existence—to explain the path that was mine to walk. Or at least that was my early rationalization. Now, I see it as more.

Now I see that my works are not merely images meant to

20

Ars Longa

One day in 2009, I thought it would be wonderful for my son to have a piece of my art on his body. So I designed a tattoo for Dominic for his eighteenth birthday. I had also designed one for my daughter, Abigail, on her eighteenth birthday. (She chose her own image, which incorporated one of her eyes into the design.) Dominic's tattoo depicted a skull with a melting candle upon its cranium above the words *carpe diem,* which is Latin for "seize the day." I wanted the same tattoo as well, but with the words *ars longa.*

Dominic was delighted with my design. "Thanks Mom, I will wear it with pride." In fact, he was so happy with it that he paid for my tattoo, fourteen days later, as a gift for my birthday! We went to a local tattoo artist to have our inking done at the same time.

I asked that my tattoo be placed on my left shoulder, while Dominic had his inked onto his chest. Half-way into the work, Dominic had to have a break because of the pain. As he got up

to go outside and have a cigarette, I joked, "I didn't get to have a break while I was giving birth to you." He smiled and walked through the door. I think he hurt too much to produce a retort.

Charlie, the tattooist, had a fascinating parlor, to say the least. It displayed curios from all over the world—shrunken heads, skulls (some of them human), and a huge tank housing chameleons, those amazing lizards that change color and whose eyes rotate independently. I felt right at home there, because my house has similar characteristics (minus the human skulls and chameleons). I have many animal skulls, preserved animals in jars, fossils, a shark's jaw, box frames containing giant moths and scorpions, and living baby scorpions, as well as my paintings hanging all over my walls. You can imagine the looks on the faces of strangers, especially builders and plumbers, who come into my house.

"I know what *carpe diem* means," the tattooist said, "but what does *ars longa* mean?"

"It's from a Latin saying: 'Art lives forever . . . although the artist dies.'"

"Well, that's really profound, I like that!" He smiled. "I had better not accidentally add an 'e' on the end of ars then."

"Better not—or *you* will die," I said with a smile.

I loved the idea of the *ars longa* tattoo. I had designed it specifically to remind me that I must produce as much art as possible before I die—because apart from living through my children, I want to live on through my art.

I want immortality. I want to leave my mark in this world, and a reason to justify my existence—to explain the path that was mine to walk. Or at least that was my early rationalization. Now, I see it as more.

Now I see that my works are not merely images meant to

obtain a reaction or provide visual pleasure; rather, they have a higher purpose: to express love and compassion towards other victims and survivors of sexual, emotional and physical abuse. I see these victims as my "brothers and sisters"—not in a blood connection, but emotionally. We are linked by the pain and anguish we shared at the hands of our abusers.

Because I possess the artistic capability to express the truth, I can help my brothers and sisters. I want them to know that even if no one else in this world cares about them, I do. And I hope that after I am long gone, my spirit will still be with future generations of abuse victims and they can turn to my art for inspiration and comfort. I hope that all I do will give me peace and comfort in the knowledge that I was meant for this world—that there was a reason *why* I experienced what I experienced.

The gift of artistic expression is my life, my very being, my all and my everything. It is how I convey the emotions that replace words I do not, or cannot, express. Painting the images that I do allows me to release and then view my feelings. By painting them, I am able to catch and hold them still so that I can study, analyze and deal with them from a different perspective. This is how art keeps me sane.

As I've said earlier in this book, I began to paint at age forty, initially as a way to purge and acknowledge my own abuse. And although I hid these "personal paintings" until May 2010, they are now available for the world to see.

Now, no one can sway me from my mission—even though my art is not always well received because it is so graphic. Now I do not mind if others condemn me for my paintings, nor if they appreciate my art.

I knew that when I decided to paint as a "true" artist that my subject matter would not sit well in this world, and would

not be commercially viable. I also knew that few if any galleries would risk exhibiting my art, and doubted that my work would ever grace the pages of mainstream art magazines.

But this no longer discourages me. My goals and aspirations are not those of my peers. I have even been encouraged to paint other subject matter, such as erotica, which sells extremely well. Although this has been tempting at times because I still struggle financially, I cannot sell out my passion and need to help others.

And then there is the suggestion of some well-meaning folks who say simply, "With your talent, why don't you paint nice things instead of all this horror?"

I smile and tell them "I paint the truth, and the truth has been the key to my freedom and happiness, as it is to others." An image of a beautiful flower does not take away a person's pain. They might feel a moment of pleasure but the pain remains, indelible. But when someone looks at my paintings they are jolted out of their apathy and the suppression of their pain, or they have the realization that it's okay to speak out; it's okay to rock the boat and expose the abusers who have kept them silent for so long. It's okay to talk about sexual abuse without shame, guilt, self blame or fear of stigmatization.

In 2009 I had an opportunity to do my first solo show in London. It was arranged by my agent, Yasha Young of the Strychnin gallery, New York, and Garry Vanderhorne of the Resistance gallery, London. They both loved and believed in my art, and felt that it should be shown.

When the day of my exhibition arrived, I stood watching people staring and saying things like, "these works are marvelous" and "the technical skill is so amazing and smooth that I thought the paintings were either airbrushed or prints, instead of originals."

One person said, "I love the way you tackle such controversial subject matter that many artists shy away from."

And another said, "You are such a visionary; no one else in this world paints like you do."

But my favorite comment was, "If Francis Bacon were alive, he would be so jealous!"

I felt like I had "arrived." I had come so far from that abused, controlled, suppressed, frightened girl I had once been, to a confident, conscientious, and vivacious woman. Here I was, living a dream I had thought would never come true. Living something I once believed only ever happened to other people.

The best feeling for me, though, was respect. Everyone there respected me as an artist, and the pride in my children's eyes as they witnessed this melted my heart.

Many people tentatively touched the canvasses. They wanted to feel the physical presence of the artist working, something you just don't get from other mediums. Paint is pure honesty. Every brush stroke has tangible meaning. It is powerfully tactile, not just in a physical sense, but within a spiritual and emotional state.

In the gallery, patrons were able to connect with my thoughts and emotions without feeling intrusive. They had been given permission to look inside my mind, a humbling privilege for me. It was the same feeling I'd gotten looking at original works such as Francis Bacon's.

My thoughts were interrupted by one of my fans whom I knew from an Internet site. "I wouldn't have missed this for the world," he said. "Your work, close up, in the flesh, is just too incredible compared to the small photos on the Internet."

"Thank you."

"So, this is your dream come true at last?"

"Well, yes it is, but I do have one other dream that I think is just impossible, and will never happen."

"Really, so what would that be?"

"To one day exhibit my personal paintings that no one has ever seen. I suspect they're way too shocking and visceral to unleash onto the public." I told him a little about them.

"Well, I for one would love to see them," he said. "You shouldn't hide your art. I'm sure lots of your admirers would love to see them too."

"I know, but they really are too personal, and I'm too afraid to show them now. Maybe one day. I want to, but I'm not ready yet."

Today my life is very different than it once was. I'm not looking for pity or sympathy. I'm not looking for anyone's approval, or for anyone to praise me or my art. Against all odds, I have grown up, become a successful parent, "found myself." My art comes without my need to justify it, or make excuses for it. This is not to say that I don't want to *explain* it; certainly I do. I want other people to understand my art, because it is from the shock of these images that viewers can best understand the depth and breadth of the horrors of abuse. Can you imagine what it must be like to be a young child and be raped repeatedly? I still can't, and it happened to me. And it continues to happen at an alarming rate every day, to thousands and thousands of children—and is often done by those who are supposed to be the child's protectors. Wouldn't these very same people stop someone breaking into a home with the intent to rape a young child? Yes—but they won't stop themselves.

Similarly, we find it horrific that young pre-teen and teen girls get shoved into prostitution or the sex slave industry, yet this also happens to thousands of girls every day.

All I need to do is look at my young grandchild and remember myself at her age, and all of the rage toward those who inflict their perversions on others makes me push harder in my art. When I hear people talking about how victims of abuse "generally" abuse their own children (which is true in *some* cases), I get vexed. Many victims go on to become the best possible parents. I, for one, would have died a thousand deaths to keep my children from harm.

This is why my mother has never known, and will never know, my children. She tells people, "My daughter is evil for keeping my grandchildren away from me."

But the reality is: I keep evil away from my children.

Although I received a lot of attention and wonderful comments for my "public" paintings, I felt an increasing need to share my "personal" works. As my friend had suggested, many people would probably connect and identify with the pain, anger and suffering embodied in those images . . . yet I couldn't forget the distressing reactions and condemnations they had received from the few people who had seen them. So I tried to forget about them, to keep them hidden out of sight.

But as time went by I grew more and more restless. Why couldn't I just let it go? Why couldn't I relish the success of my other art, and be grateful to the people who appreciated it?

Finally, one night in March 2010, I thought, *What if I should die and no one ever sees them?* and decided to post two of the personal images on my Facebook profile. If I could not shout out my own abuse, how could I expect others to talk about theirs? So, hesitantly, I clicked "upload."

My heart thumped in my chest as I began to receive comments. To my relief and joy, they were amazing. People identified with the work and applauded my courage for creating them.

Now I have hope that these paintings—all forty-two of them—will one day be placed on display together. Displayed, but not sold. My children have promised that they will not try to sell the canvases, even after my death. These images are my life story captured on canvas, and should only ever be exhibited, and never be separated. Each picture belongs to the collection; indeed, each belong to the world, which has the right to see them intact and in their original state, every painful brush stroke visible.

I posted more and more images of my personal paintings, placing them in an album entitled "The Things That People Don't Like to Talk About." Ironically, I couldn't bring myself to write captions explaining these works until I received many more heartfelt messages of encouragement.

On the 24th of April of that year, I posted "One of My Mother's Boyfriends," which depicted Ron, the man who had abused me when I was six. One of the comments about this painting came from Claudia Lifland, a professor of psychotherapists at a Florida university. She remarked on how hard it must have been for me to publicly expose my images of abuse.

We began chatting via private messages, and she asked me if I would mind if she used one of my paintings in her teaching group. I said yes, of course—after all, my mission was to enlighten as many people as possible. Soon Claudia and I were embarking on a collaboration that would affect the entire field of abuse as well as help victims and survivors.

Realizing that my insight into abuse could benefit the whole spectrum of therapy and social work, Claudia developed a way to utilize my art in a teaching program and as part of a therapy course for young victims and survivors. I was enthralled

to be involved in such a ground-breaking effort. Our alliance could lead to a greater study of abuse and its consequences, and hopefully bridge the gap that has so long thwarted communication between therapists and victims of abuse. Instead of young trainee social workers learning only from theorists and random case studies, they could interview and interact with me, a living source who had experienced and overcome many forms of abuse.

We began our collaboration with Claudia interviewing me to gain some initial understanding of my experiences, followed by live video conversations in which we had long discussions about how to merge my work into the teaching program of social workers. The class was split into groups of two and threes, with each group choosing one of my paintings relating to a particular subject such as pedophilia, depression, secondary victimization and human trafficking.

I was then asked to answer in detail approximately one hundred questions about my experiences, observations and thoughts. After the students received and digested my answers, they were to prepare a class presentation that incorporated their chosen painting and stated why it had been chosen, how it related to the topic, and what it suggested to my life experience. They then had to review my interview process and feedback, and relay the implications for social work practice: interventions, therapeutic approaches and additional areas for research.

Also, as part of the group presentation, members had to develop and facilitate a brief art therapy group intervention, based on their chosen painting. The main goal of this project was to get the student to think critically, connect my real-life story with the theoretical concepts of the course, and relate with me in a meaningful way.

"*This experience has taught me that ugliness and horror has a face, a literal depiction of itself through Suzzan's work. It's okay to remember and even relive those traumatic happenings and use those experiences as stepping stones to help you become a better, stronger person. Art, music, writing, or any medium can help articulate unspoken feelings.*"
—*Angie Nofal*

"*For the first time in my life I was able to put down on a piece of paper a situation that I always felt guilty about . . . when in reality I was not, I was taken advantage of. Thanks to the encouragement of hearing Suzzan's story I was able to process those emotions.*"

—*Joseth Miranda*

"*Suzzan's story helped me realize that therapy is not the only way a person can cope with abuse. Suzzan's story was powerful and helped me confront and process some of my past abuse. I have always been scared to have children. I was convinced that I would abuse them because I was abused. It gives me hope to see that Suzzan was severely abused and does not abuse her children.*"
–*Anonymous student.*

I felt honored to be a part of the learning process of these enthusiastic and appreciative students. Claudia Lifland transfigured my insular state into one of endless possibilities.

My story has just begun.

Epilogue

After I completed the first draft of this book and read through the entire thing for the first time, I had dinner with my son. As I started to eat, I became choked with emotion and burst into tears. I had not realized that I still had an incredible amount of residue left within me. Being forced to relive my story in great detail had been far harder, and I think more cathartic, than simply painting my experiences. This just goes to show the impact that my abuse still has on me, even though I thought I had overcome everything that had happened. Clearly I will always have the scars, but I no longer have the open wounds, which are the most painful.

I now believe there can never be total closure. Traumas like these do indeed become scars—mental scars that never really disappear. We have to live with them. Maybe from time to time, when the past rears its ugly head, we must simply embrace the pain—because like it or not it is a part of our minds. Instead of trying to suppress it, we must accept it as we would a good memory. It will never go away, and like a malignant cancer, will keep eating away at you if you don't acknowledge its existence.

We must also embrace the *consolations* of abuse. By this I mean those things that make us what we are because we have been abused, such as a profound appreciation of life. I, for one, feel incredibly lucky to be alive; it's not until you know ultimate darkness that you can really feel the incredible light.

What they say is true: "What doesn't kill you makes you stronger." If I hadn't gone through the things that I had as a girl, I probably would not have coped so well with the other traumas in my life. Abuse made me into the person and artist that I am today. I have known the good, the bad and the ugly of life, and that has made me into a whole person.

I am determined to show other victims of abuse that they can turn theirs around, too. We do not have to stay in that dark place that our abusers left us in; we can climb out, and indeed put our abusers in the dark—by daring to tell the world exactly what they did to us.

Sexual crimes are still largely taboo, unpalatable and anti-pathetic, a fact almost as painful as the abuse itself. This must change. I paint pictures of pedophiles, rapists, perpetrators of abuse and pornographers, and I write about "the things that people don't want to talk about" because they *should* be talked about. These atrocities against human beings should be faced, understood and dealt with. Child abuse is a root cause of many of life's sufferings and problems, ranging from depression, suicide, anger, alcoholism, and drug dependency to prostitution, promiscuity, and self-harm.

When it comes to your children, ignorance is not bliss.

About the Author

Suzzan Blac is an English surreal artist who paints images of physical, mental and sexual abuse in a most visceral and direct way. She is an intransigent protagonist who fights on behalf of victims and survivors of abuse to aid their personal recovery, to jolt the apathy of society and enlighten those who impose secondary victimization, which can be as painful as the abuse itself. Suzzan's work is used in teaching programs to further understanding and insight into the whole spectrum of abuse and as an inspiring facet in helping abuse victims in group therapy. For more information, see *www.suzzanb.com.*

Other Books by
Bettie Youngs Book Publishers

On Toby's Terms

Charmaine Hammond

On Toby's Terms is an endearing story of a beguiling creature who teaches his owners that, despite their trying to teach him how to be the dog they want, he is the one to lay out the terms of being the dog he needs to be. This insight would change their lives forever.

Simply a beautiful book about life, love, and purpose. —Jack Canfield, compiler, *Chicken Soup for the Soul* series

In a perfect world, every dog would have a home and every home would have a dog like Toby! —Nina Siemaszko, actress, *The West Wing*

This is a captivating, heartwarming story and we are very excited about bringing it to film. —Steve Hudis, Producer

ISBN: 978-0-9843081-4-9 • $14.95

The Maybelline Story—And the Spirited Family Dynasty Behind It

Sharrie Williams

Throughout the twentieth century, Maybelline inflated, collapsed, endured, and thrived in tandem with the nation's upheavals. Williams, to avoid unwanted scrutiny of his private life, cloistered himself behind the gates of his Rudolph Valentino Villa and ran his empire from a distance. This never before told story celebrates the life of a man whose vision rocketed him to success along with the woman held in his orbit: his brother's wife, Evelyn Boecher— who became his lifelong fascination and muse. A fascinating and inspiring story, a tale both epic and intimate, alive with the clash, the hustle, the music, and dance of American enterprise.

A richly told story of a forty-year, white-hot love triangle that fans the flames of a major worldwide conglomerate. —Neil Shulman, Associate Producer, *Doc Hollywood*

Salacious! Engrossing! There are certain stories, so dramatic, so sordid, that they seem positively destined for film; this is one of them. —*New York Post*

ISBN: 978-0-9843081-1-8 • $18.95

Blackbird Singing in the Dead of Night
What to Do When God Won't Answer

Gregory L. Hunt

Pastor Greg Hunt had devoted nearly thirty years to congregational ministry, helping people experience God and find their way in life. Then came his own crisis of faith and calling. While turning to God for guidance, he finds nothing. Neither his education nor his religious involvements could prepare him for the disorienting impact of the experience.

Alarmed, he tries an experiment. The result is startling—and changes his life entirely.

In this most beautiful memoir, Greg Hunt invites us into an unsettling time in his life, exposes the fault lines of his faith, and describes the path he walked into and out of the dark. Thanks to the trail markers he leaves along the way, he makes it easier for us to find our way, too. —Susan M. Heim, co-author, *Chicken Soup for the Soul, Devotional Stories for Women*

Compelling. If you have ever longed to hear God whispering a love song into your life, read this book. —Gary Chapman, *NY Times* bestselling author, *The Love Languages of God*

ISBN: 978-1-936332-07-6 • $15.95

It Started with Dracula
The Count, My Mother, and Me

Jane Congdon

The terrifying legend of Count Dracula silently skulking through the Transylvania night may have terrified generations of filmgoers, but the tall, elegant vampire captivated and electrified a young Jane Congdon, igniting a dream to one day see his mysterious land of ancient castles and misty hollows. Four decades later she finally takes her long-awaited trip—never dreaming that it would unearth decades-buried memories, and trigger a life-changing inner journey. A memoir full of surprises, Jane's story is one of hope, love—and second chances.

Unfinished business can surface when we least expect it. *It Started with Dracula* is the inspiring story of two parallel journeys: one a carefully planned vacation and the other an astonishing and unexpected detour in healing a wounded heart. —Charles Whitfield, MD, bestselling author of *Healing the Child Within*

An elegantly written and cleverly told story. An electrifying read. —Diane Bruno, CISION Media

ISBN: 978-1-936332-10-6 • $15.95

Diary of a Beverly Hills Matchmaker

Marla Martenson

Marla takes her readers for a hilarious romp through her days in an exclusive matchmaking agency. From juggling the demands of out-of-touch clients and trying to meet the capricious demands of an insensitive boss to the ups and downs of her own marriage with a husband who doesn't think that she is "domestic" enough, Marla writes with charm and self-effacement about the universal struggles of finding the love of our lives—and knowing it.

Martenson's irresistible quick wit will have you rolling on the floor.
—Megan Castran, international YouTube Queen

ISBN: 978-0-9843081-0-1 • $14.95

Hostage of Paradox: A Memoir

John Rixey Moore

A profound odyssey of a college graduate who enlists in the military to avoid being drafted, becomes a Green Beret Airborne Ranger, and is sent to Vietnam where he is plunged into high-risk, deep-penetration operations under contract to the CIA—work for which he was neither specifically trained nor psychologically prepared, yet for which he is ultimately highly decorated. Moore survives, but can't shake the feeling that some in the military didn't care if he did, or not. Ultimately he would have a 40-year career in television and film.

A compelling story told with extraordinary insight, disconcerting reality, and engaging humor. —David Hadley, actor, *China Beach*

ISBN: 978-1936332-37-3 • $24.95

DON CARINA
WWII Mafia Heroine

Ron Russell

A father's death in Southern Italy in the 1930s—a place where women who can read are considered unfit for marriage—thrusts seventeen-year-old Carina into servitude as a "black widow," a legal head of the household who cares for her twelve siblings. A scandal forces her into a marriage to Russo, the "Prince of Naples."

By cunning force, Carina seizes control of Russo's organization and disguising herself as a man, controls the most powerful of Mafia groups for nearly a decade. Discovery is inevitable: Interpol has been watching. Nevertheless, Carina survives to tell her children her stunning story of strength and survival.

978-0-9843081-9-4 • $15.95

Living with Multiple Personalities
The Christine Ducommun Story

Christine Ducommun

Christine Ducommun was a happily married wife and mother of two, when—after moving back into her childhood home—she began to experience panic attacks and a series of bizarre flashbacks. Eventually diagnosed with Dissociative Identity Disorder (DID), Christine's story details an extraordinary twelve-year ordeal unraveling the buried trauma of her past and the daunting path she must take to heal from it. Therapy helps to identify Christine's personalities and understand how each helped her cope with her childhood, but she'll need to understand their influence on her adult life.

Fully reawakened and present, the personalities compete for control of Christine's mind as she bravely struggles to maintain a stable home for her growing children. In the shadows, her life tailspins into unimaginable chaos—bouts of drinking and drug abuse, sexual escapades, theft and fraud—leaving her to believe she may very well be losing the battle for her sanity. Nearing the point of surrender, a breakthrough brings integration.

A brave story of identity, hope, healing and love.

Reminiscent of the Academy Award-winning *A Beautiful Mind*, this true story will have you on the edge of your seat. Spellbinding! —**Josh Miller**, Producer

ISBN: 978-0-9843081-5-6 • $16.95

Amazing Adventures of a Nobody

Leon Logothetis

Tired of his disconnected life and uninspiring job, Leon leaves it all behind—job, money, home even his cell phone—and hits the road with nothing but the clothes on his back. His journey from Times Square to the Hollywood sign relying on the kindness of strangers and the serendipity of the open road, inspires a dramatic and life changing transformation.

A gem of a book; endearing, engaging and inspiring. —**Catharine Hamm,** *Los Angeles Times* Travel Editor

Leon reaches out to every one of us who has ever thought about abandoning our routines and living a life of risk and adventure. His tales of learning to rely on other people are warm, funny, and entertaining. If you're looking to find meaning in this disconnected world of ours, this book contains many clues. —*Psychology Today*

ISBN: 978-0-9843081-3-2 • $14.95

Truth Never Dies

William C. Chasey

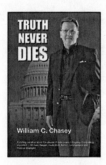

A lobbyist for some 40 years, William C. Chasey represented some of the world's most prestigious business clients and twenty-three foreign governments before the US Congress. His integrity never questioned.

All that changed when Chasey was hired to forge communications between Libya and the US Congress. A trip he took with a US Congressman for discussions with then Libyan leader Muammar Qadhafi forever changed Chasey's life. Upon his return, his bank accounts were frozen, clients and friends had been advised not to take his calls.

Things got worse: the CIA, FBI, IRS, and the Federal Judiciary attempted to coerce him into using his unique Libyan access to participate in a CIA-sponsored assassination plot of the two Libyans indicted for the bombing of Pan Am flight 103. Chasey's refusal to cooperate resulted in the destruction of his reputation, a six-year FBI investigation and sting operation, financial ruin, criminal charges, and incarceration in federal prison.

A somber tale, a thrilling read. —Gary Chafetz, author, *The Perfect Villain: John McCain and the Demonization of Lobbyist Jack Abramoff*

ISBN: 978-1-936332-46-5 • $24.95

Out of the Transylvania Night

Aura Imbarus

A Pulitzer-Prize entry.

"I'd grown up in the land of Transylvania, homeland to Dracula, Vlad the Impaler, and worse, dictator Nicolae Ceausescu," writes the author. "Under his rule, like vampires, we came to life after sundown, hiding our heirloom jewels and documents deep in the earth." Fleeing to the US to rebuild her life, she discovers a startling truth about straddling two cultures and striking a balance between one's dreams and the sacrifices that allow a sense of "home."

Aura's courage shows the degree to which we are all willing to live lives centered on freedom, hope, and an authentic sense of self. Truly a love story! —Nadia Comaneci, Olympic Champion

A stunning account of erasing a past, but not an identity. —Todd Greenfield, 20th Century Fox

ISBN: 978-0-9843081-2-5 • $14.95

Fastest Man in the World

Tony Volpentest
Foreword by Ross Perot

Tony Volpentest is a four-time Gold Medalist and five-time World Champion sprinter. He carried the Olympic flame at the 1996 Atlanta Olympics. But it is not so much the medals he sports that make him admirable; it is the grit and determination that got him there. Though born without hands or feet, he is the fastest runner in the world. Tony shares his incredible journey, from the feet that Ross Perot built for him, to his 2012 induction into the Olympic Hall of Fame.

This inspiring story is about the thrill of victory to be sure—winning Olympic Gold—but it is also a reminder about human potential: the ability to push ourselves beyond the ledge of imagination, and to develop grit that fuels indefatigable determination. Simply a powerful story. —Charlie Huebner, United States Olympic Committee

ISBN 978-1-936332-00-7 • $16.95

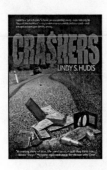

Crashers
A Tale of "Cappers" and "Hammers"

Lindy S. Hudis

The illegal business of fraudulent car accidents is a multi-million dollar racket, involving unscrupulous medical providers, personal injury attorneys, and the cooperating passengers involved in the accidents. Innocent people are often swept into it.

Newly engaged Nathan and Shari, who are swimming in mounting debt, were easy prey: seduced by an offer from a stranger to move from hard times to good times in no time, Shari finds herself the "victim" in a staged auto accident. Shari gets her payday, but breaking free of this dark underworld will take nothing short of a miracle.

A riveting story of love, life—and limits. A non-stop thrill ride. —**Dennis "Danger" Madalone, stunt coordinator for the television series,** *Castle*

ISBN: 978-1-936332-27-4 $16.95

In bookstores everywhere, online, Espresso, or from the publisher, Bettie Youngs Books:

www.BettieYoungsBooks.com